The Nature
of Photographs

Phaidon Press Limited

Regent's Wharf

All Saints Street

London N1 9PA

Phaidon Press Inc.

180 Varick Street

New York, NY 10014

www.phaidon.com

Second edition (revised, expanded and redesigned)

© 2007 Phaidon Press Limited

First edition published by The Johns Hopkins

University Press

ISBN 978 0 7148 4585 2

A CIP catalogue record for this book is available
from the British Library.

Design and Typeface by A2/SW/HK

Printed in China

The Nature
of Photographs

By Stephen Shore

Contents

Robert Frank
<u>View from Hotel Window</u>
— Butte, Montana
1954—56

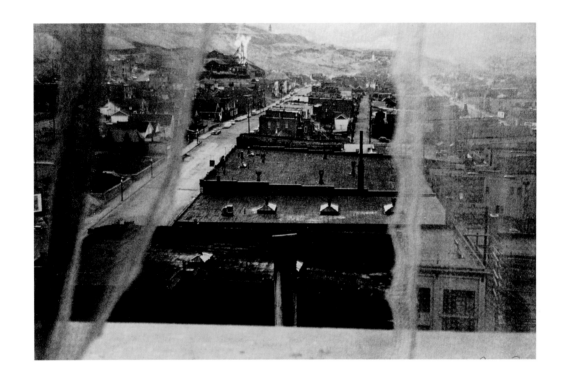

The Nature
of Photographs

How is this photograph different
from the actual scene that Robert Frank
saw as he stood in his Butte hotel room
and looked out on this depressed mining
town in the northern Rockies? How
much of this image is a product of
lenses, shutters, and media? What
are the characteristics of photography
that establish how an image looks?

This book explores ways of understanding
the nature of photographs; that is, how
photographs function; and not only the
most elegant or graceful photographs,
but all photographs made with a camera
and printed directly from the negative
or a digital file. All photographic prints
have qualities in common. These qualities
determine how the world in front of the
camera is transformed into a photograph;
they also form the visual grammar that
elucidates the photograph's meaning.

John Gossage
Romance Industry # 175
1998

A photograph can be viewed on several
levels. To begin with, it is a physical
object, a print. On this print is an
image, an illusion of a window on to the
world. It is on this level that we usually
read a picture and discover its content:
a souvenir of an exotic land, the face of
a lover, a wet rock, a landscape at night.
Embedded in this level is another that
contains signals to our mind's perceptual
apparatus. It gives 'spin' to what the
image depicts and how it is organized.

Dieter Appelt
The Mark on the Mirror
That Breathing Makes
1977

The aim of this book then is not to explore photographic content, but to describe physical and formal attributes of a photographic print that form the tools a photographer uses to define and interpret that content.

Walker Evans
Family Snapshots in
Frank Tongue's Home,
Hale County, Alabama
1936

Anonymous
<u>Car by roadside</u>
Date unknown

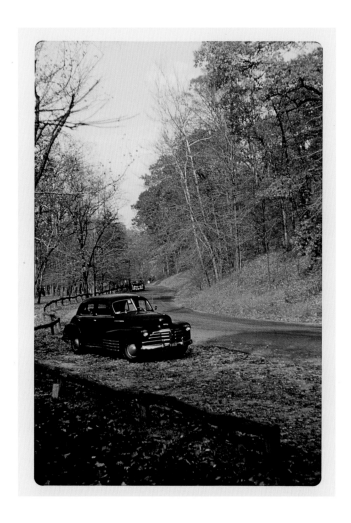

The Physical Level

A photographic print is, in most
instances, a base of paper, plastic,
or metal that has been coated with
an emulsion of light-sensitive metallic
salts or metallic salts coupled with
vegetable or metallic dyes. In some
prints, the base is coated directly
with or imprinted with dyes, pigments,
or carbon. A photograph is flat, it has
edges, and it is static; it doesn't move.
While it is flat, it is not a true plane.
The print has a physical dimension.

These physical and chemical attributes
form the boundaries that circumscribe
the nature of the photograph. These
attributes impress themselves upon
the photographic image. The physical
qualities of the print determine some
of the visual qualities of the image.
The flatness of the photographic paper
establishes the plane of the picture.
The edges of the print demand the
boundedness of the picture. The staticness
of the image determines the experience
of time in the photograph. Even the
image of a photograph on a computer
monitor is flat, static, and bounded.
The type of black-and-white emulsion
determines the hue and tonal range
of the print. The type of base determines
the texture of the print.

Stephen Shore
Luzzara, Italy, 1993

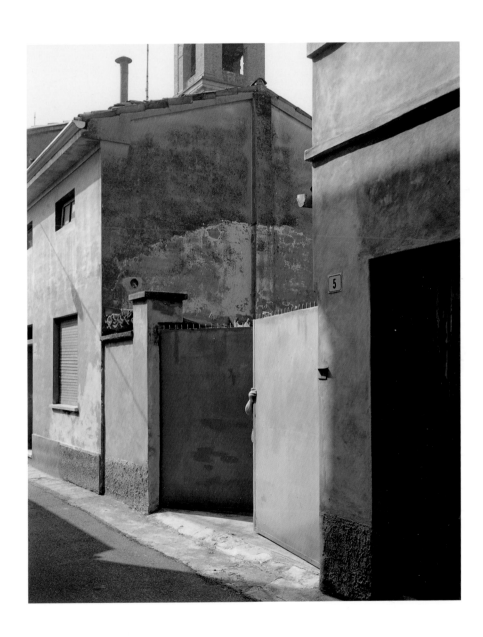

Colour expands a photograph's palette
and adds a new level of descriptive
information and transparency to the
image. It is more transparent because
one is stopped less by the surface — colour
is more like how we see. It has added
description because it shows the colour
of light and the colours of a culture or an
age. While made in the 1980s, the palette
of this image by Anne Turyn seems to
date the picture a generation earlier.

Anne Turyn
12 • 17 • 1960
From
'Flashbulb Memories'
1986

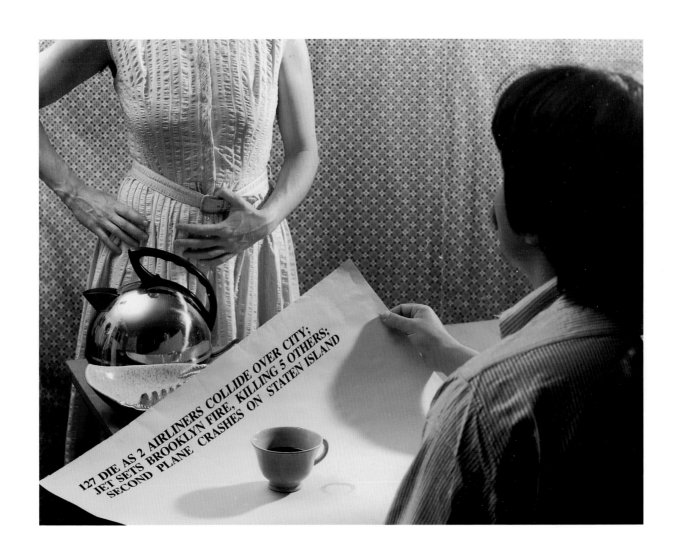

Stephen Shore
<u>Room 28, Holiday Inn,</u>
<u>Medicine Hat, Alberta,</u>
<u>August 18, 1974</u>

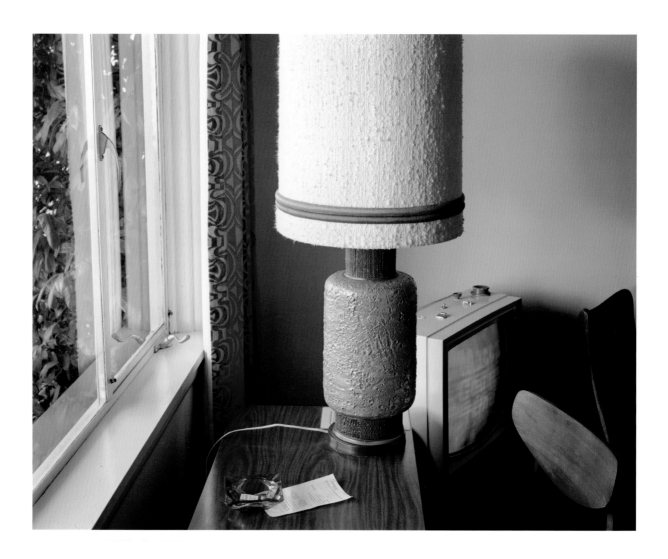

Joel Sternfeld
McLean, Virginia,
December 1978

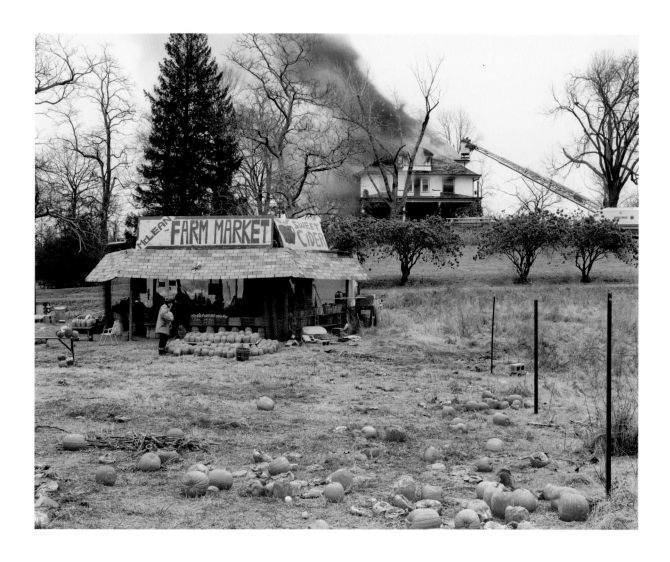

Stephen Shore

<u>Amarillo, Texas, 1972</u>

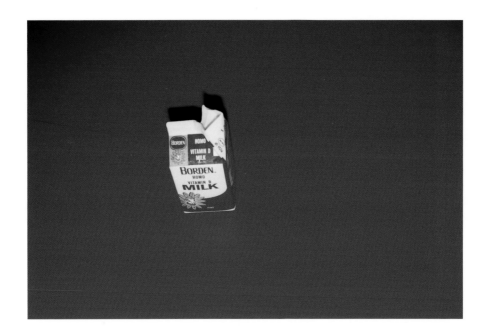

Thomas Demand
Sink/Spüle
1997

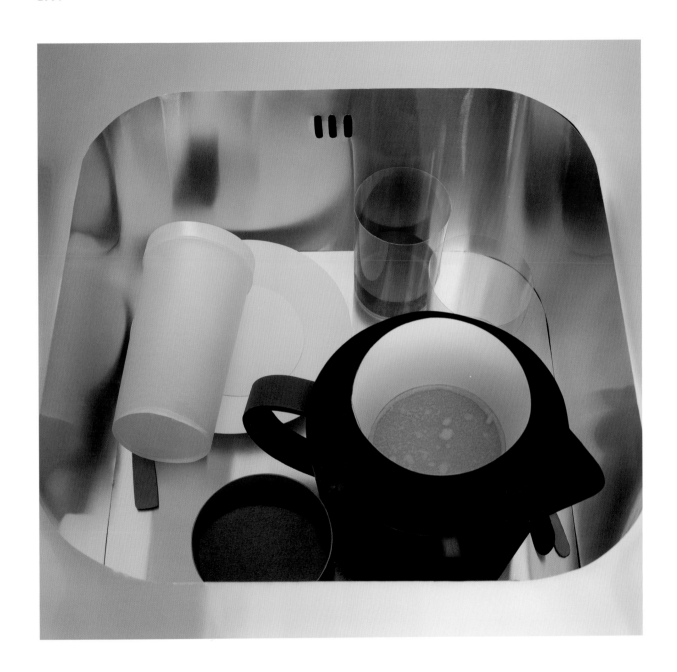

The tonal range of a black-and-white
print is affected by the type of emulsion
the print is made with. The composition
of the film emulsion, the chemistry
of the film and print developers,
and the nature of the light source from
which the print was made also determine
the way shadows, mid tones, and
highlights are described by the print;
they determine how many shades of
grey the print contains and whether
these tones are compressed or separated.

This reproduction of a print by Richard
Benson has an exceptionally long
tonal scale with subtle, clear, beautiful
separation of the low values. The
original print is acrylic paint applied
to aluminium. It was produced from
eight halftone separations made from
the original negative.

Richard Benson
Untitled
Date unknown

As an object, a photograph has its
own life in the world. It can be saved
in a shoebox or in a museum. It can
be reproduced as information or as
an advertisement. It can be bought and
sold. It may be regarded as a utilitarian
object or as a work of art. The context
in which a photograph is seen effects
the meanings a viewer draws from it.

Anonymous
Old man with apples
Date unknown

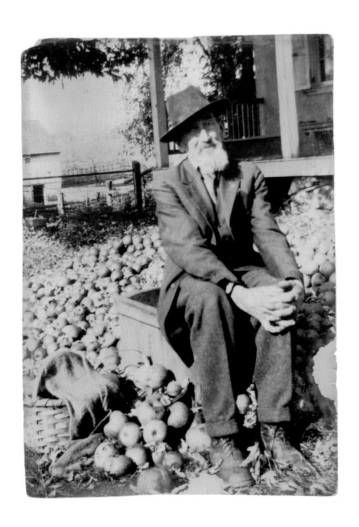

Cindy Sherman
Untitled Film Still
1978

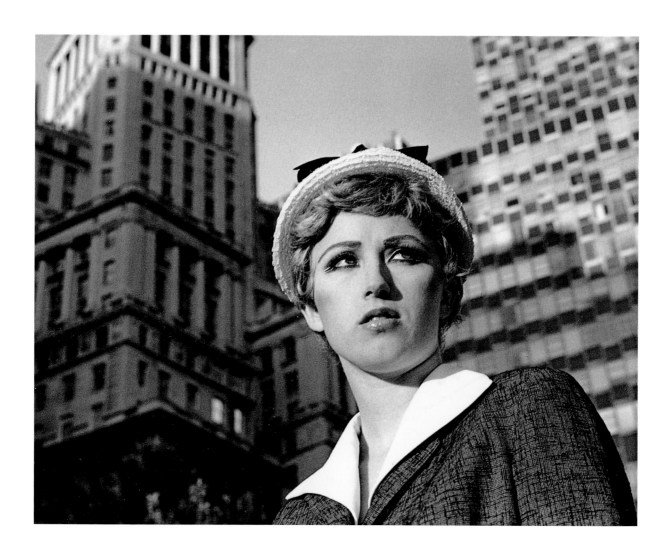

Anonymous
Publicity shot of actress
Joan Fontaine
1953

CUTE FELLOW: Joan Fontaine cuddles her "No Dice"
Mexican Hairless pup, during a lull in shooting
of Nat Holt's "Flight To Tangier" at Paramount.

(PLEASE CREDIT "FLIGHT TO TANGIER")

T. H. O'Sullivan
Historic Spanish Record
of the Conquest, South
Side of Inscription Rock,
New Mexico
1873

U.S. Geological Survey
Longitudinal, parabolic,
and transverse dunes
on Garces Mesa Coconino
County, Arizona, Lat
35°39' N; long 110°55' W
Photograph scale:
1:54,000, Feb. 19th, 1954

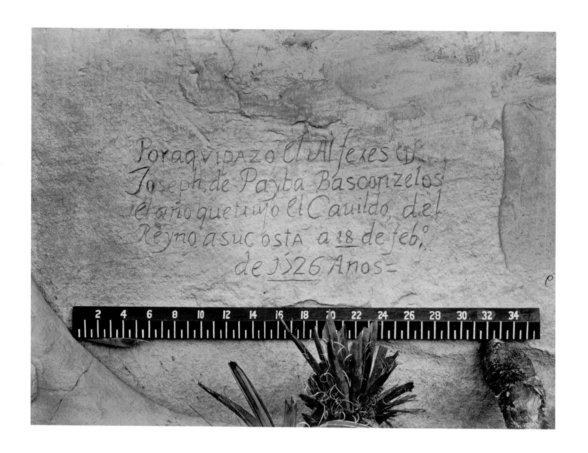

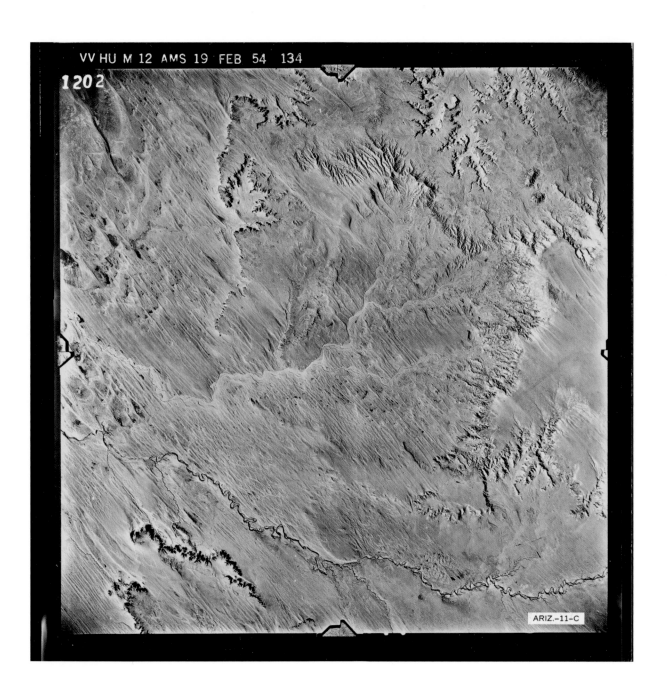

VV HU M 12 AMS 19 FEB 54 134

1202

ARIZ.-11-C

Collier Schorr
Herbert, New Soldier,
Goethestrasse
2001

Bernd and Hilla Becher
Watertowers,
1972—1986

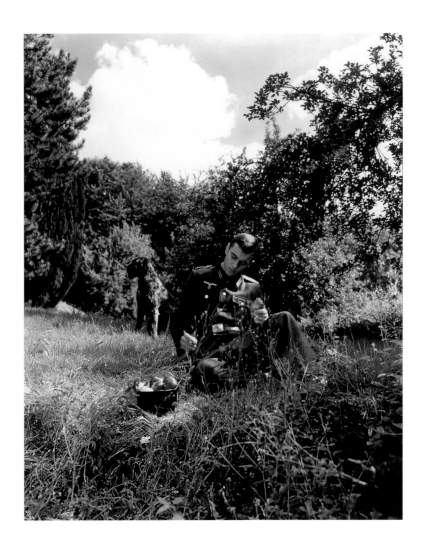

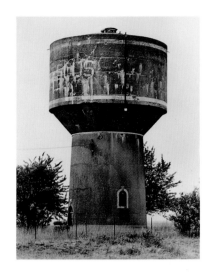 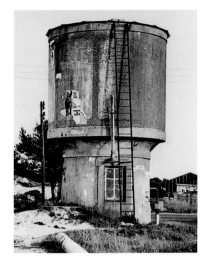 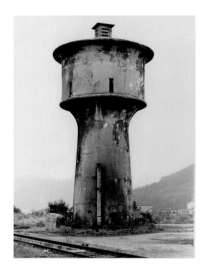

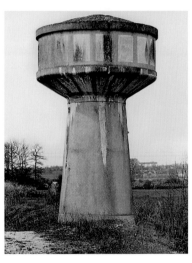 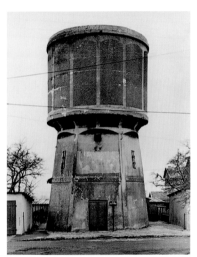 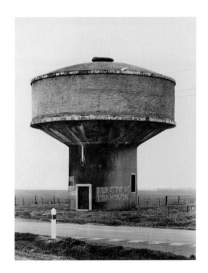

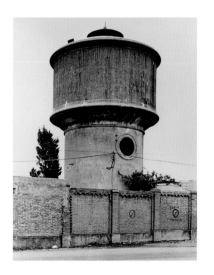 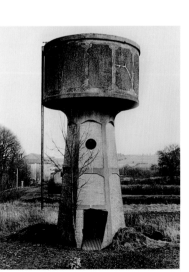 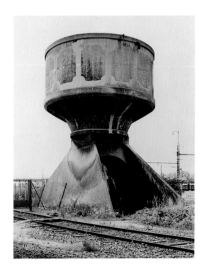

By consciously adopting a visual style,
a photographer can reference this
context and bring these meanings to
the reading of the image, as Walker
Evans did when he made this photograph
in, what he called, 'documentary style'.

Walker Evans
Bed, Tenant Farmhouse,
Hale County, Alabama
1935

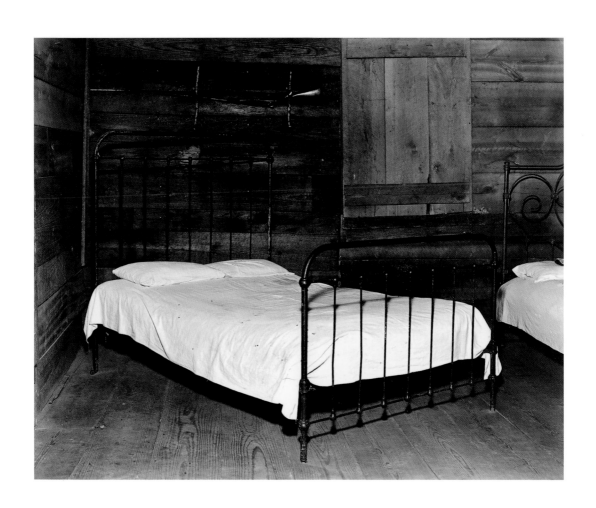

Andrew Moore
Burger King, Governor's
Island, New York
2003

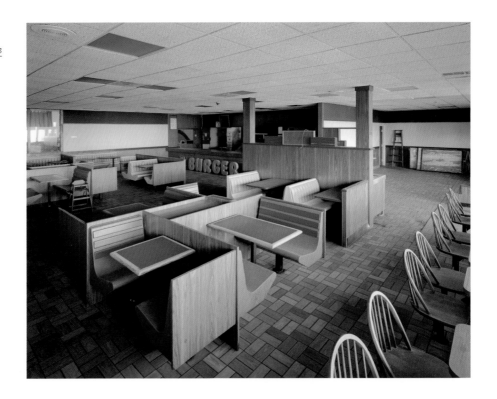

Lisa Kereszi
Burger King, Governor's
Island, New York
2003

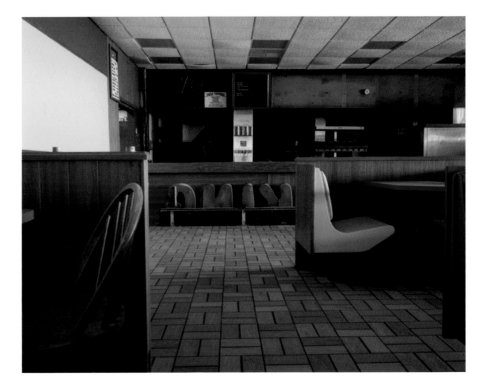

The
Depictive
Level

Photography is inherently an analytic
discipline. Where a painter starts with
a blank canvas and builds a picture,
a photographer starts with the messiness
of the world and selects a picture. A
photographer standing before houses and
streets and people and trees and artifacts
of a culture imposes an order on the
scene — simplifies the jumble by giving
it structure. He or she imposes this order
by choosing a vantage point, choosing
a frame, choosing a moment of exposure,
and by selecting a plane of focus.

The photographic image depicts, within
certain formal constraints, an aspect
of the world. This photograph by Evans
depicts a store, gas pumps, a car, a road,
hills and houses, sky. It also depicts
receding space.

The formal character of the image is a
result of a range of physical and optical
factors. These are the factors that define
the physical level of the photograph.
But on the depictive level there are
four central ways in which the world
in front of the camera is transformed
into the photograph: flatness, frame,
time, and focus.

These four attributes define the picture's
depictive content and structure. They
form the basis of a photograph's visual
grammar. They are responsible for
a snapshooter's 'mistakes': a blur,
a beheading, a jumble, an awkward
moment. They are the means by which
photographers express their sense of the
world, give structure to their perceptions
and articulation to their meanings.

Walker Evans
Mining Town,
West Virginia
1936

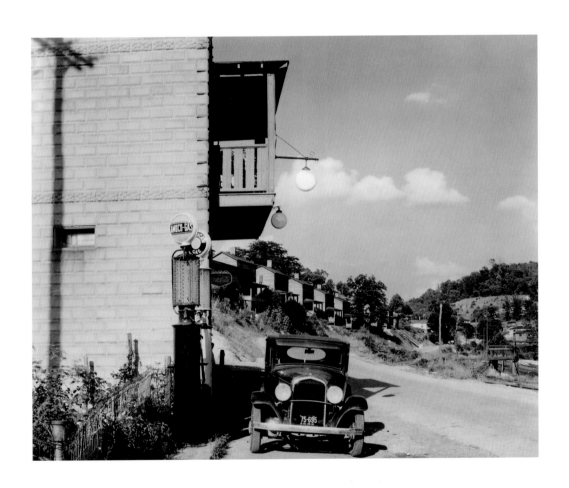

The first means of transformation
is flatness. The world is three-
dimensional; a photographic image
is two-dimensional. Because of this
flatness, the depth of depictive space
always bears a relationship to the
picture plane. The picture plane is
a field upon which the lens's image
is projected. A photographic image
can rest on this picture plane and,
at the same time, contain an illusion
of deep space.

C. E. Watkins
Castle Rock, Columbia
River, 1867

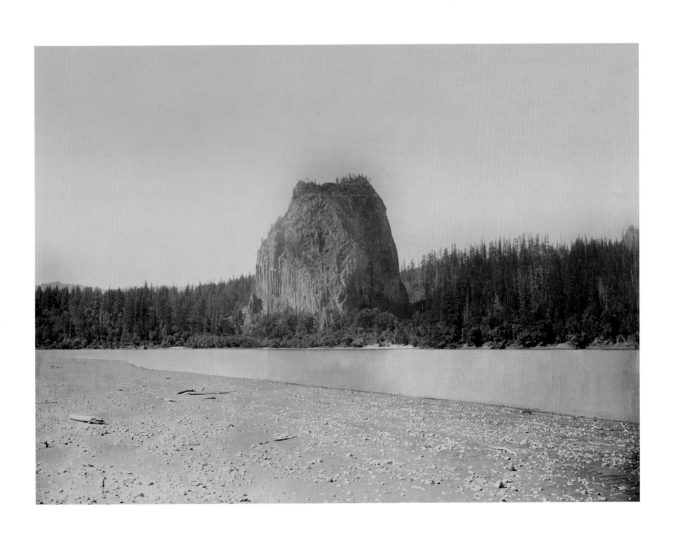

Photographs have (with the exception
of stereo pictures) monocular vision
— one definite vantage point. They
do not have the depth perception that
our binocular vision affords us. When
three-dimensional space is projected
monocularly on to a plane, relationships
are created that did not exist before the
picture was taken. Things in the back of
the picture are brought into juxtaposition
with things in the front. Any change
in the vantage point results in a change
in the relationships. Anyone who has
closed one eye, held a finger in front of
his or her face, and then switched eyes
knows that even this two-inch change
in vantage point can produce a dramatic
difference in visual relationships.

To say that new relationships are
created does not mean that the yield
sign and cloud in this photograph
by Lee Friedlander were not there
in front of the camera, but that
the visual relationship between them,
the cloud sitting like cotton candy
on top of the sign, is a product of
photographic vision.

Lee Friedlander
Knoxville, Tennessee,
1971

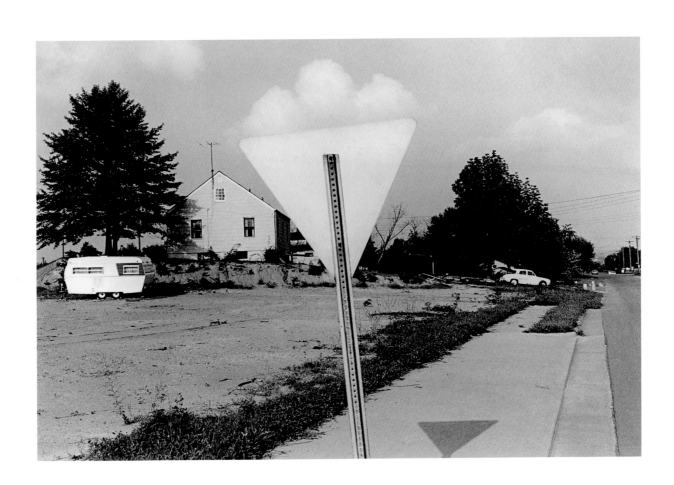

Some photographs are opaque.
The viewer is stopped by the
picture plane.

Thomas Struth
Paradise 9
(Xi Shuang Banna),
Yunnan Province,
China
1999

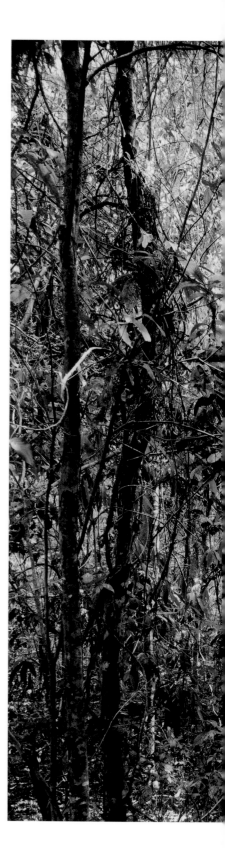

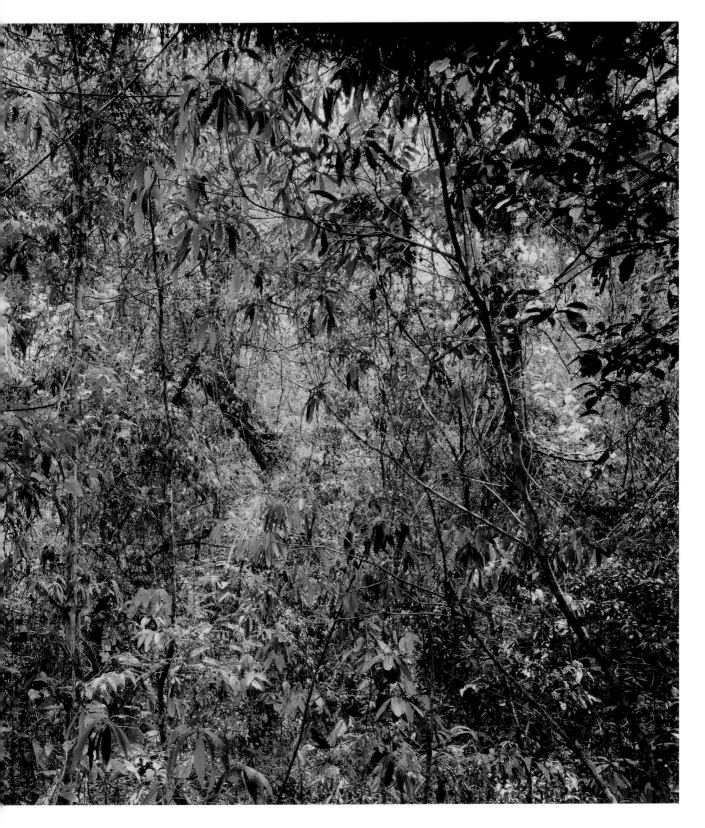

Some photographs are transparent.
The viewer is drawn through
the surface into the illusion of
the image.

Thomas Struth
Pantheon, Rome
1990

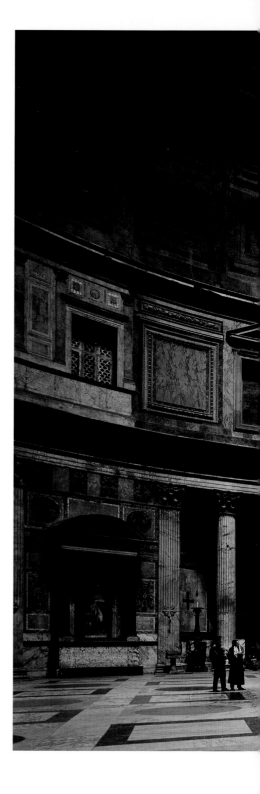

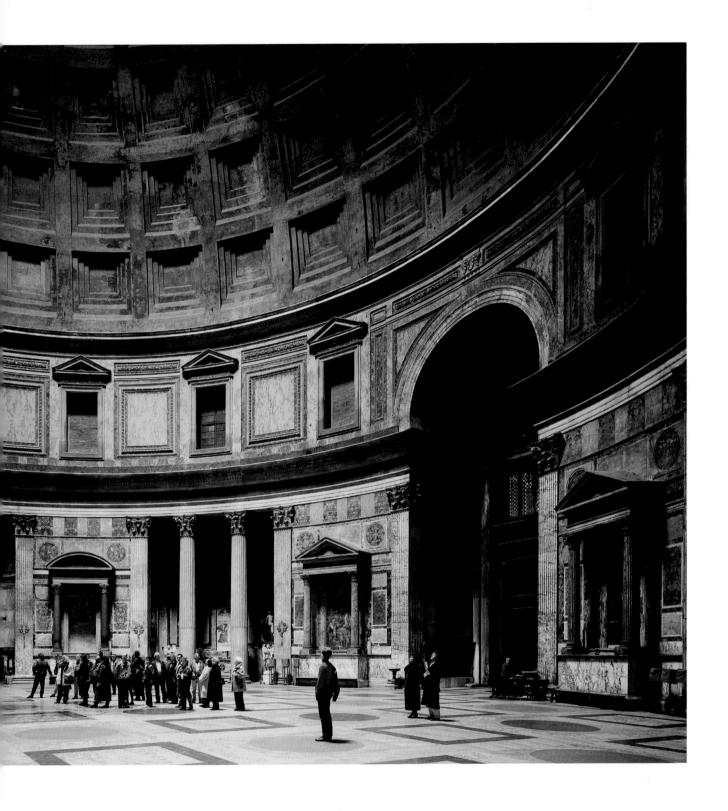

In the field, outside the controlled
confines of a studio, a photographer is
confronted with a complex web of visual
juxtapositions that realign themselves
with each step the photographer takes.
Take one step and something hidden
comes into view; take another and an
object in the front now presses up against
one in the distance. Take one step and
the description of deep space is clarified;
take another and it is obscured.

André Kertész
Dubo, Dubon,
Dubonnet, Paris, 1934

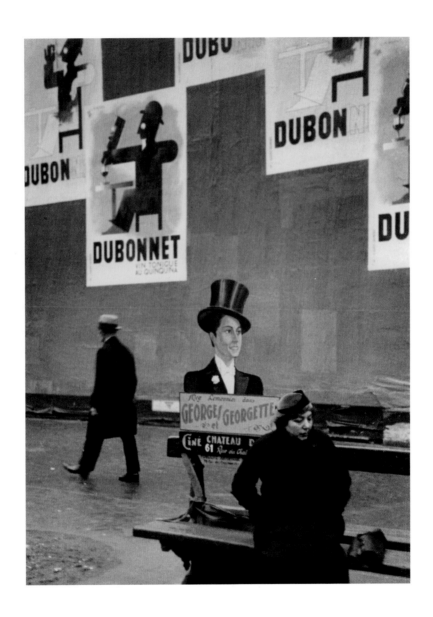

Lisette Model
Sammy's Bar, 1940

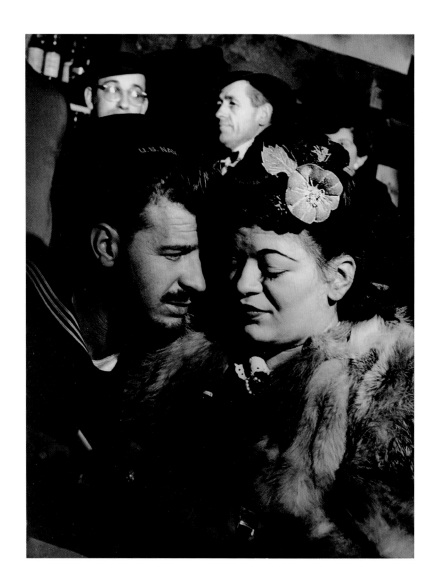

Zeke Berman
<u>Domestic Still Life,</u>
<u>Art and Entropy</u>
1979

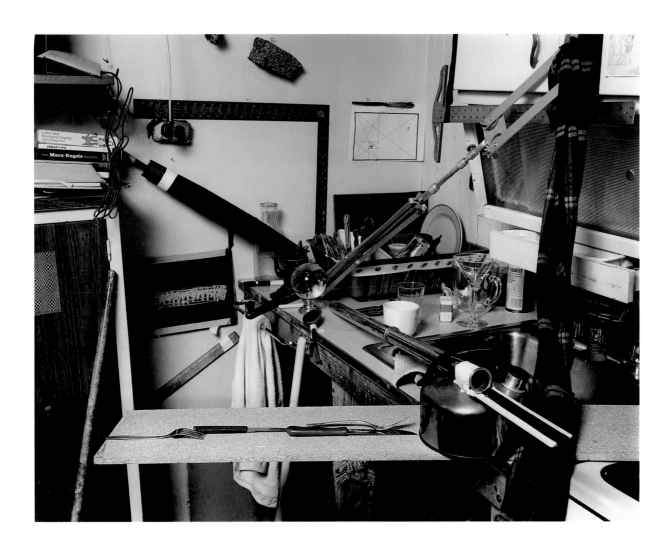

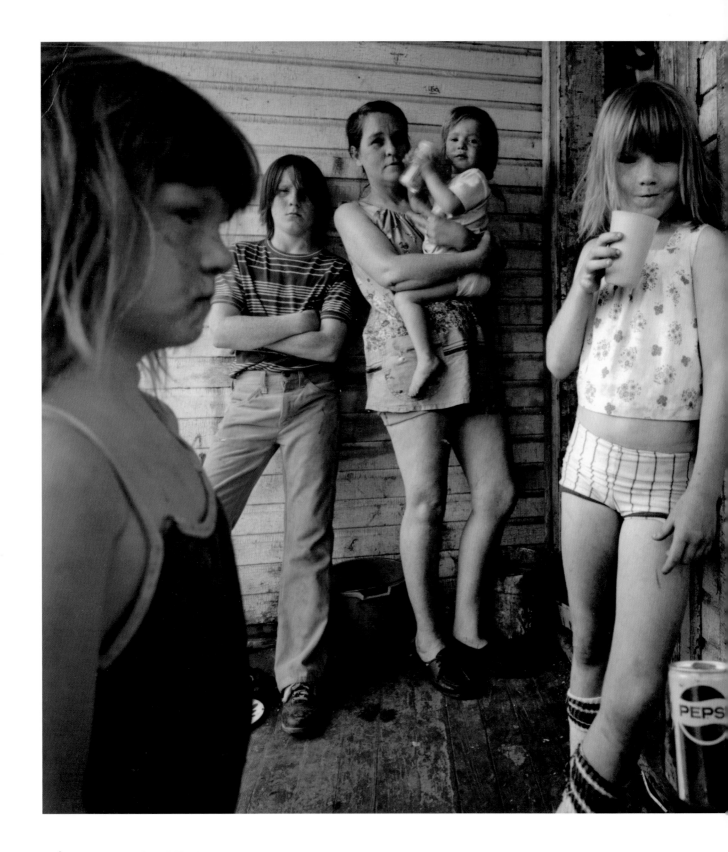

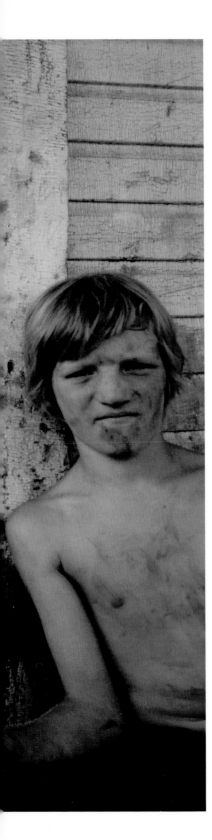

Nicholas Nixon
<u>Friendly,</u>
<u>West Virginia,</u>
<u>1982</u>

In bringing order to this situation,
a photographer solves a picture,
more than composes one.

The next transformative element
is the frame. A photograph has edges;
the world does not. The edges separate
what is in the picture from what
is not. Robert Adams could aim his
camera down a little bit and to the
right, include a railroad track in this
photograph of a partially clear-cut
Western landscape, and send a chilling
reverberation through the image's
content and meaning.

Robert Adams
Clear-cut along
the Nehalem River,
Tillamook County,
Oregon
1976

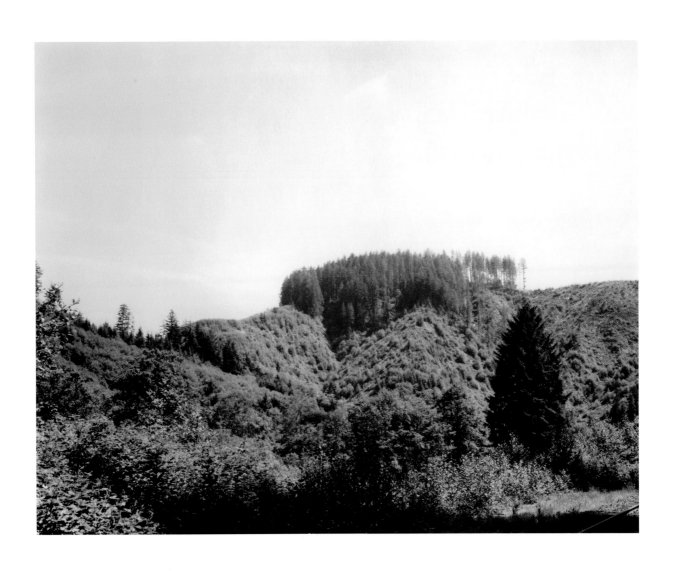

The frame corrals the content of the photograph all at once. The objects, people, events, or forms that are in the forefront of a photographer's attention when making the fine framing decisions are the recipients of the frame's emphasis. The frame resonates off them and, in turn, draws the viewer's attention to them.

Just as monocular vision creates juxtapositions of lines and shapes within the image, edges create relationships between these lines and shapes and the frame. The relationships that the edges create are both visual and 'contentual'.

Aaron Diskin
The Shadow
1995

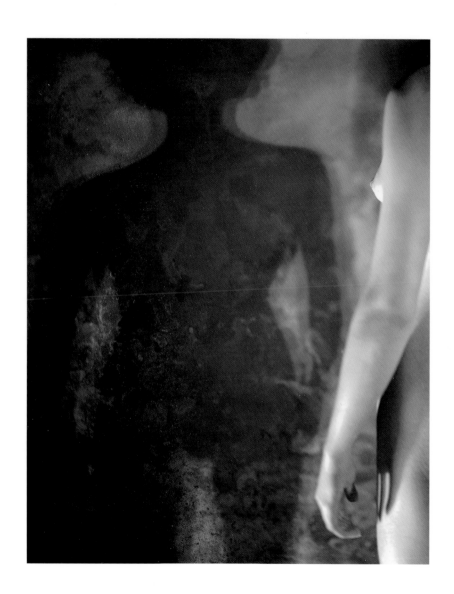

The men in the foreground of this
photograph by Helen Levitt bear a
visual relationship not only to each
other, but also to the lines of the frame.
The frame energizes the space around
the figures. These formal qualities
unite the disparate action of this picture,
the seated man with his stolid stare,
the languid dialogue of the two on the
left, and the streetwise angularity of
the central figure, into the jazzy cohesion
of 1940s New York City street life.

Helen Levitt
New York
c. 1945

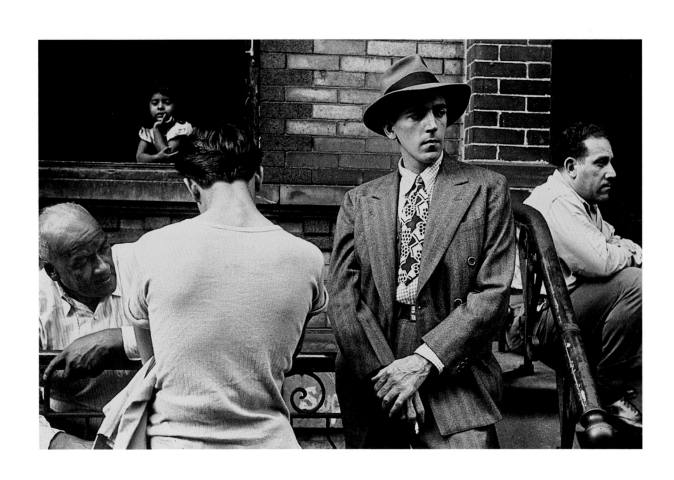

For some pictures the frame acts
passively. It is where the picture ends.
The structure of the picture begins
within the image and works its way
out to the frame.

As the street in this photograph by
William Eggleston leads to a pine wood
beyond the sub-division's boundaries,
so the photograph's structure implies
a world continuing beyond its edges.

William Eggleston
Untitled
c. 1970

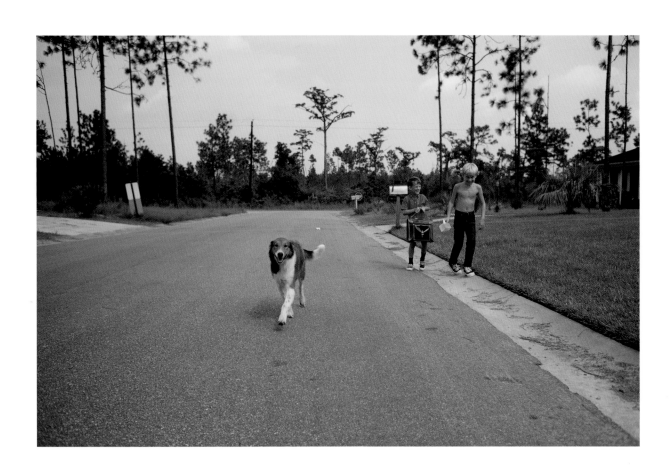

For some pictures the frame is active.
The structure of the picture begins
with the frame and works inward.

While we know that the buildings,
sidewalks, and sky continue beyond
the edges of this urban landscape, the
world of the photograph is contained
within the frame. It is not a fragment
of a larger world.

Stephen Shore
El Paso Street,
El Paso, Texas, 1975

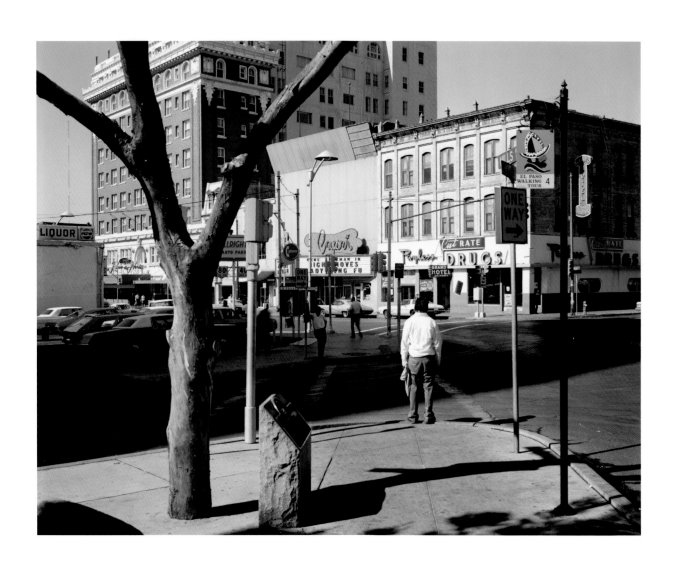

Japanese woodblock prints use the frame in a way that is more reminiscent of photographs than of Western painting. It has been suggested that this was a result of the Eastern scroll tradition — seeing the infinitely variable croppings that occur when viewing a scroll as it is rolled from hand to hand. Perhaps by examining what gives these prints their sense of photographic framing we can clarify what photographic framing is.

Notice how, in the upper right of the picture, the frame gives emphasis to the angel's hand staying the sword. The angel is described with the greatest economy: the artist has given the least information needed for us to read this being as an angel. There is something slyly wonderful about our ability to make an interpretation based on this minimal description.

Now, notice the leg jutting into the image from the lower right. It is really amazing that the artist chose to add this. It doesn't relate to any of the action in the picture. It is entirely extraneous. It typifies the sort of seemingly arbitrary cropping that occurs when the frame of a photograph slices through the world. While it doesn't relate to the unfolding drama of the picture, it does imply that this drama is a part of a larger world.

Toyokuni III (Kunisada)
Scene from a Kabuki play
c. 1850

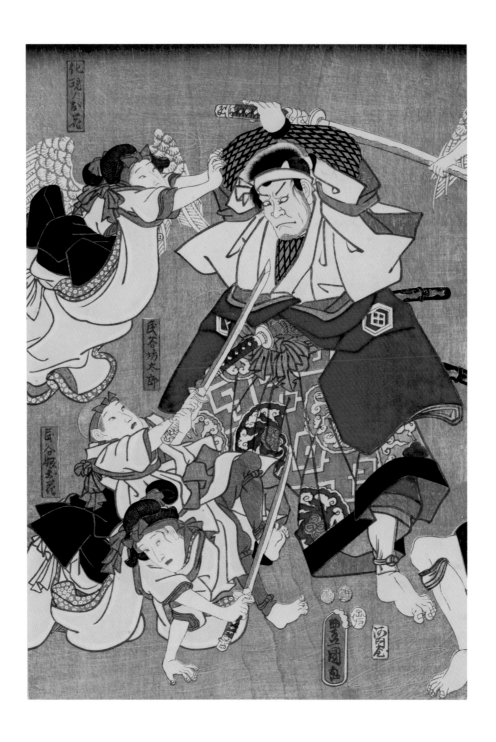

Paul Graham
Untitled, Spain, 1988
(coins on shelf)

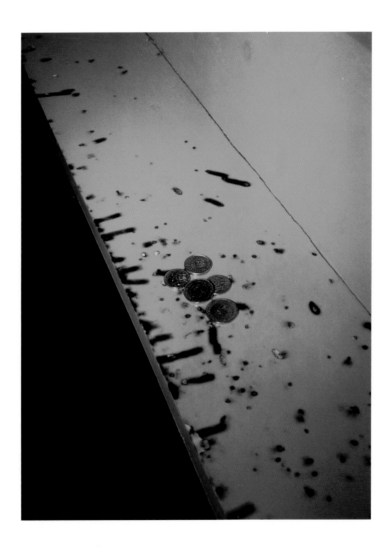

Philip-Lorca diCorcia
Hartford, 1979

Richard Prince
<u>Untitled (Cowboy)</u>
1989

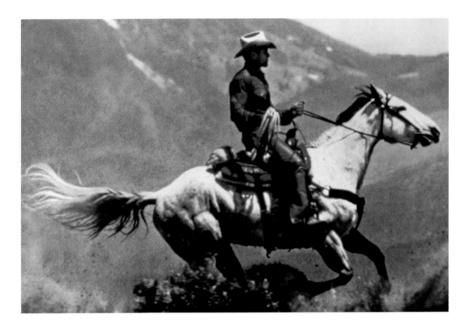

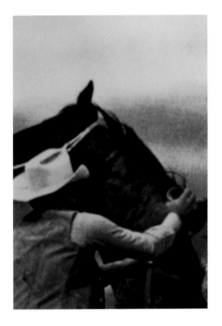 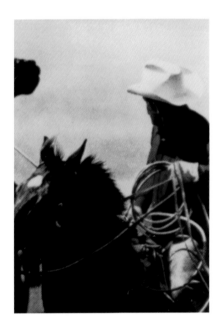

Richard Prince
<u>Untitled (Cowboys 4)</u>
1987
Detail

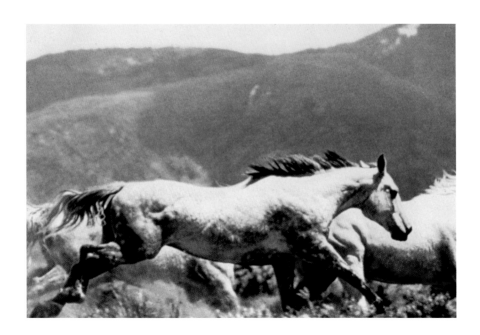

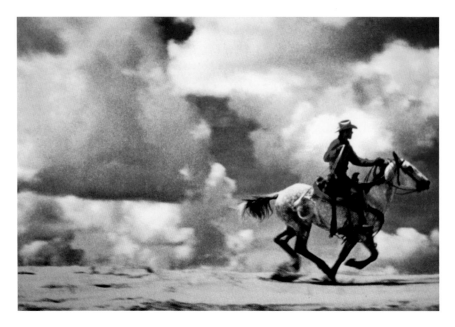

Richard Prince
Untitled (Cowboy)
1980—89

Someone saying 'cheese' when having
a portrait made acknowledges uncon-
sciously the way time is transformed
in a photograph. A photograph is static,
but the world flows in time. As this
flow is interrupted by the photograph,
a new meaning, a photographic meaning,
is delineated. The reality is a person
saying 'cheese'. The camera, bearing
mute witness, depicts a person smiling
— perhaps a shallow, lifeless smile
like one in a yearbook portrait or a
ribbon-cutting ceremony, but a smile
nonetheless. Say 'crackers' and the
camera will see a sneer.

At the Texas State Fair, one day in
1964, a steer was swinging his head
back and forth and flicking his tongue.
His handler was ducking, trying to
avoid the beast. Amid the flux of all
this motion, there was one instant,
one two hundred and fiftieth of a second,
when, seen from a single vantage point
and recorded on a static piece of film,
the steer's tongue and the brim of
his handler's Stetson met in perfect
symmetry; an instant that, as quickly
as it arose, dissolved back into disorder.

Garry Winogrand
Texas State Fair, Dallas,
1964

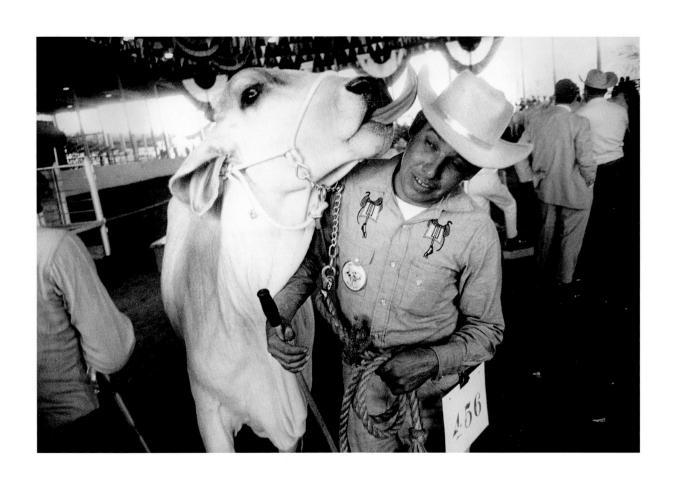

Two factors affect time in a photograph:
the duration of the exposure and the
staticness of the final image. Just as a
three-dimensional world is transformed
when it is projected on to a flat piece
of film, so a fluid world is transformed
when it is projected on to a static piece
of film. The exposure has a duration, what
John Szarkowski in <u>The Photographer's
Eye</u> called 'a discrete parcel of time'.
The duration of the exposure could be ...

<u>Larry Fink
Studio 54, New York
City, May 1977</u>

one ten thousandth of a second ...

Frozen time: an exposure of short
duration, cutting across the grain
of time, generating a new moment.

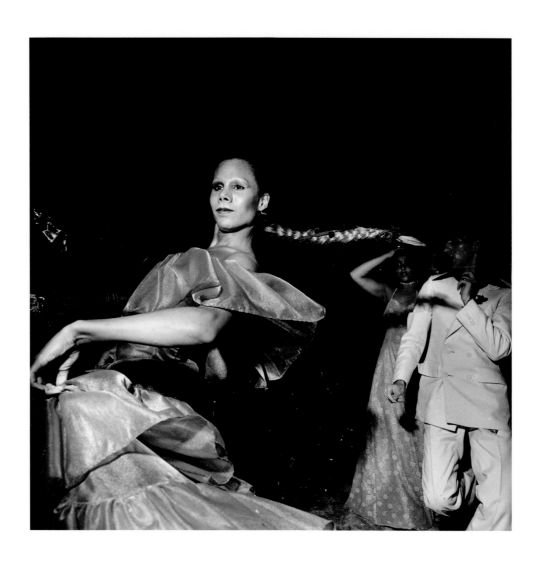

or two seconds ...

Extrusive time: the movement occurring
in front of the camera, or movement
of the camera itself, accumulating on
the film, producing a blur.

Linda Connor
Sleeping Baby,
Kathmandu, Nepal, 1980

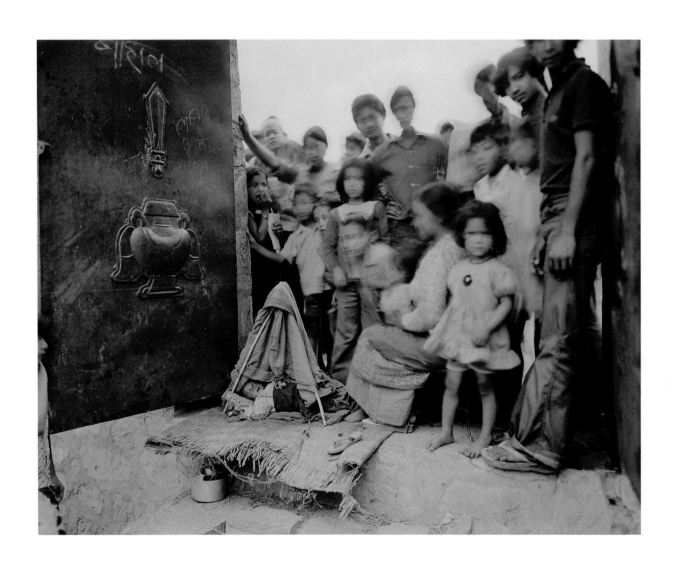

... or six minutes.

Still time: the content is at rest and time is still.

Edward Weston
<u>Pepper, 1930</u>

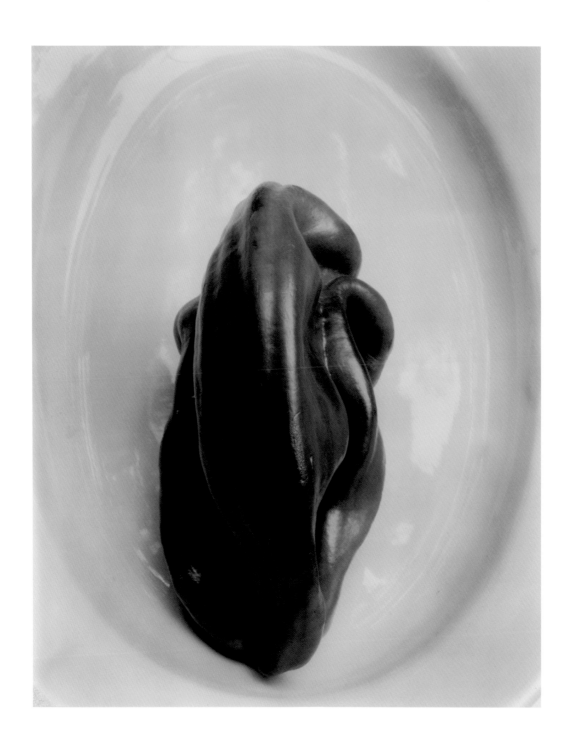

Tod Papageorge
Zuma Beach, California,
1978

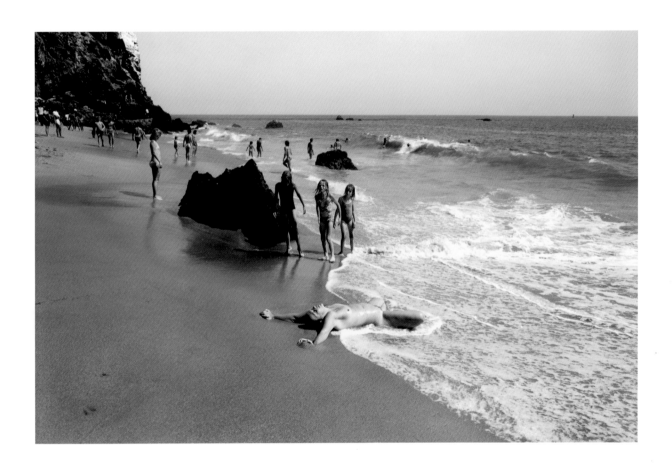

Frank Gohlke

Aftermath: the Wichita Fall, Texas, Tornado no. 10A, Maplewood Ave., near Sikes Center Mall, Looking East, April 14, 1979/Aftermath: the Wichita Fall, Texas, Tornado no. 10B, Maplewood Ave., near Sikes Center Mall, Looking East, June, 1980

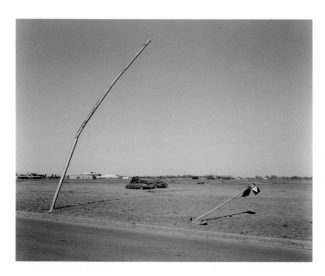 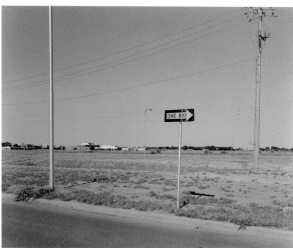

Bob Mulligan
[Richard Nixon the Day
after the Hiss Verdict]
1950

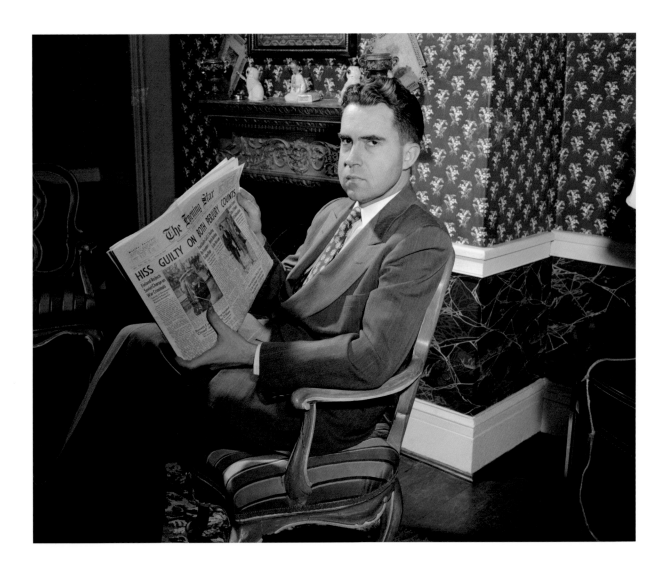

Michael Schmidt
From
'Waffenruhe'
1985–87

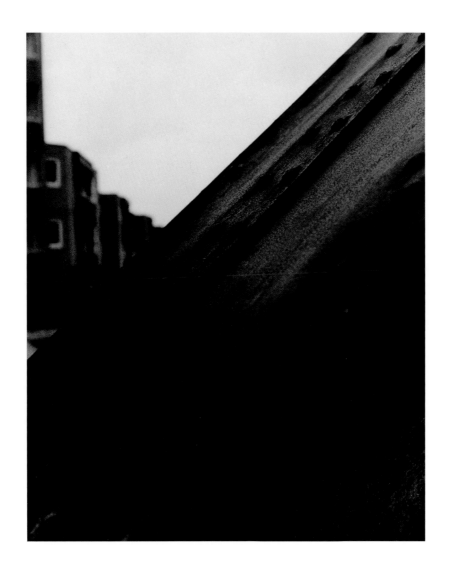

Focus is the fourth major transformation
of the world into a photograph. Not
only does a camera see monocularly from
a definite vantage point; it also creates
a hierarchy in the depictive space by
defining a single plane of focus. This
plane, which is usually parallel with
the picture plane, gives emphasis to
part of the picture and helps to distil
a photograph's subject from its content.

In this photograph by P. H. Emerson,
the shallow area in focus — the image's
depth of field — draws the viewer's
awareness immediately to the three reed
harvesters in the foreground. It isolates
them from the fourth harvester and from
the marshes in the background. The plane
of focus acts as the edge of our attention
cutting through the scene.

P. H. Emerson
<u>During the Reed Harvest</u>
1886

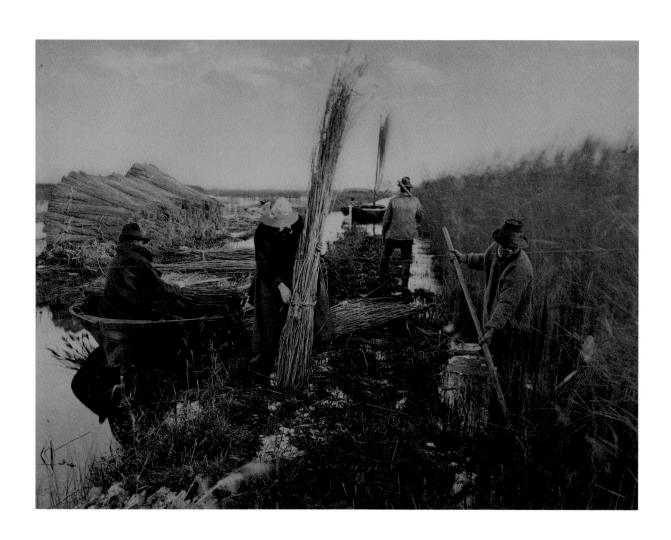

Examine this photograph by Robert
Adams. Move your attention from the
bottom edge, back through the parking
lot, to the movie screen. From the screen,
move your attention to the mountain
to its right and from there to the sky.

Follow the same path through the picture,
but now be aware that as your eye moves
back through the parking lot — as your
attention recedes through the depictive
space — you have a sensation of changing
focus, your eyes focusing progressively
further away.

Notice that as your attention moves from
the screen to the mountain there is little
or no change of focus.

Notice that as your attention moves from
the mountain to the sky there is a shift
of focus, but now, instead of moving back,
your focus is seemingly moving forward,
coming closer.

Notice that the direction and speed
of your refocusing is not tied to the
recession in depictive space. The clouds
may be further away than the movie
screen, but your focus moves closer.

Robert Adams
Outdoor Theater and
Cheyenne Mountain
1968

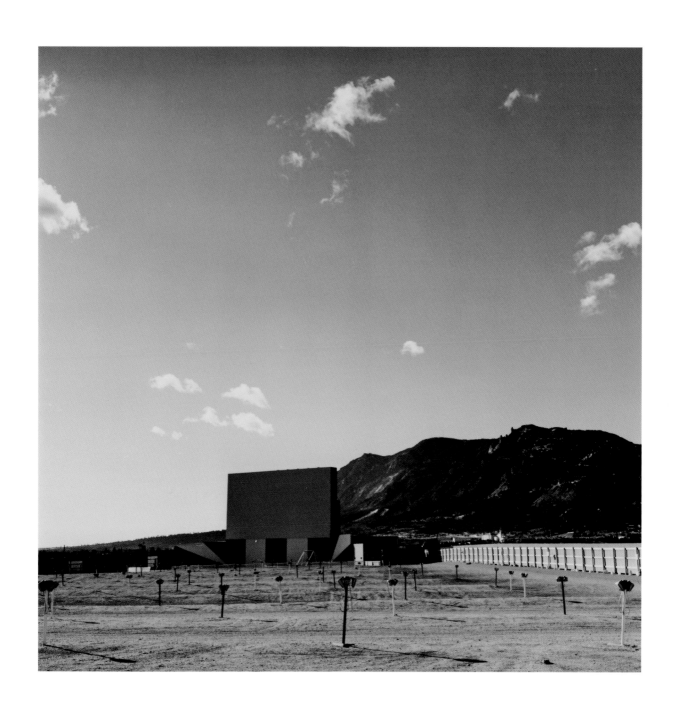

While with most cameras the lens is
attached to a rigid camera body and so
bears a fixed relationship to the picture
plane, with a traditional view camera
the lens, which is attached to flexible
bellows, can be pivoted sideways or up
and down. This allows the plane of focus
to be manipulated so that it is no longer
parallel to the picture plane. It can even
run perpendicular to the picture plane,
as in this still life by Jan Groover.

Jan Groover
Untitled
1985

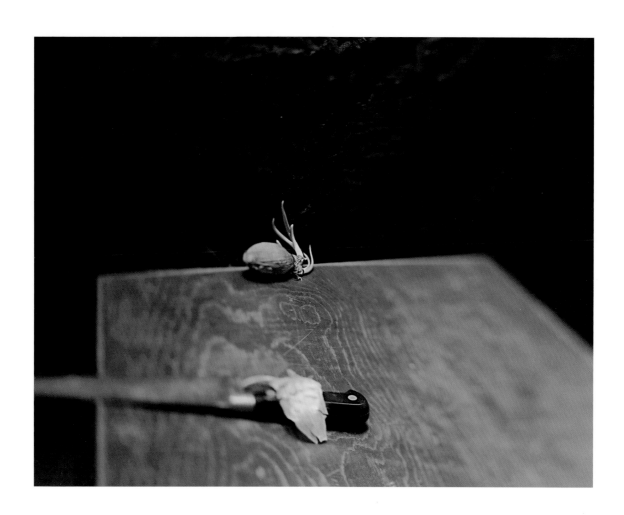

The Depictive Level: Focus | 87

The spatial hierarchy generated by the
plane of focus can be eliminated only by
photographing a flat subject that is itself
parallel to the picture plane.

Brassaï
Graffiti
c. 1935

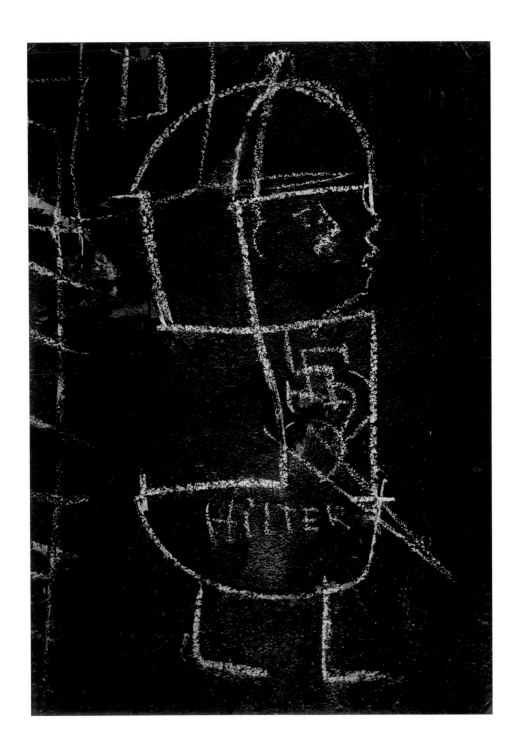

The hierarchical emphasis created by
the plane of focus can be minimized
by increasing the depth of field. But
there is still one plane that is in focus,
with space before and behind rendered
with diminishing sharpness. There is
a gravitation of attention to the plane
of focus. Attention to focus concentrates
our attention.

Judith Joy Ross
From
'Easton Portraits'
1988

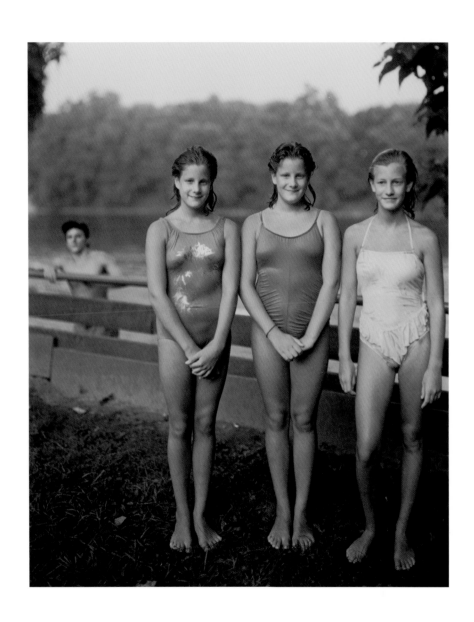

Anonymous
Publicity still from
'Docks of New Orleans',
starring Roland Winters
as Charlie Chan
1948

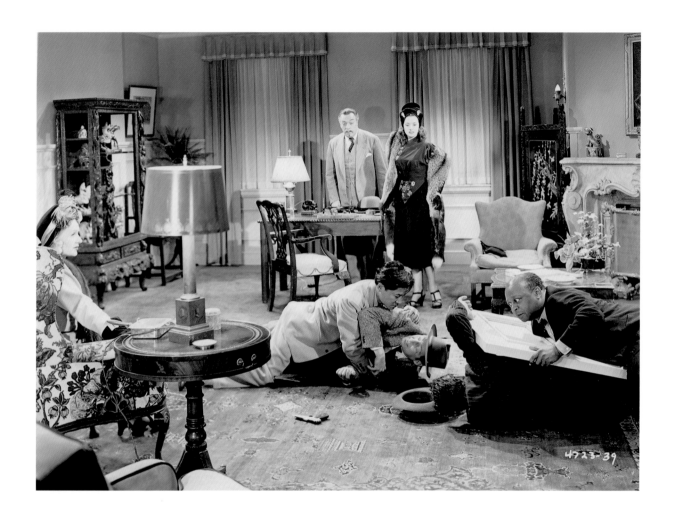

Vik Muniz
Action Photo
(After Hans Namuth)
1997

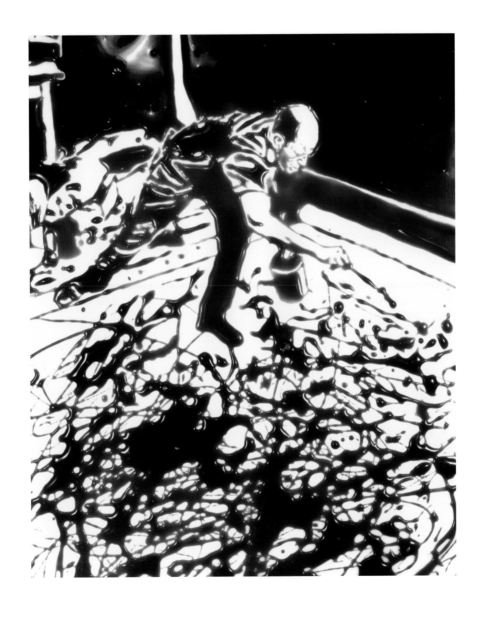

Mitch Epstein
Untitled, New York, 1998

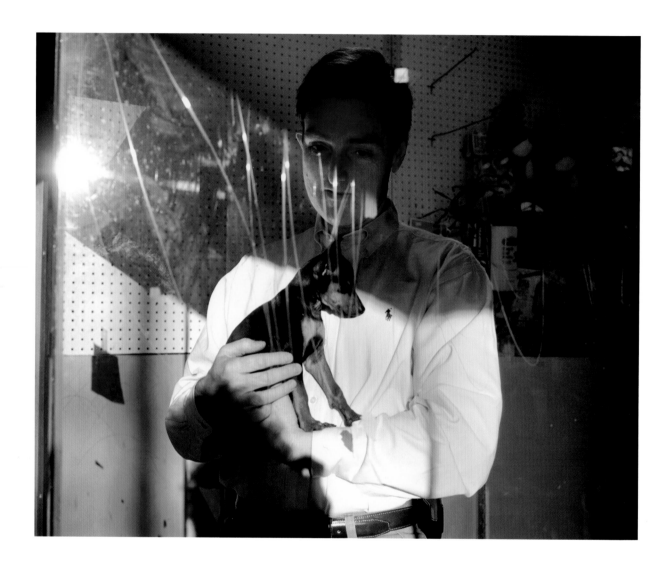

Guido Guidi
<u>Rimini Nord, 1991</u>

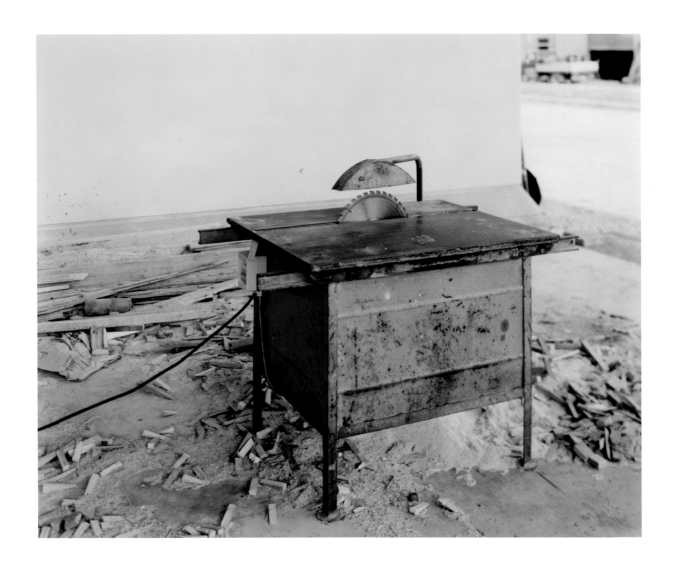

Paul Caponigro
<u>Death Valley,</u>
<u>California, 1975</u>

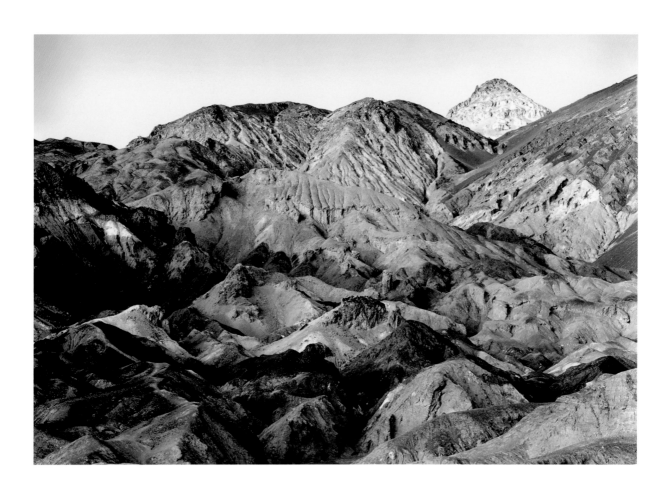

The Mental Level

You see a mental image — a mental construction — when you read this page, or look at a photograph, or see anything else in the world. Your focus even shifts when reading this picture by Paul Caponigro. But your eyes don't actually refocus (since you are only looking at a flat page). It is your mind that changes focus within your mental image of the picture, with all the attendant sensations of refocusing your eyes. It is your mental focus that is shifting.

Light reflecting off this page is focused by the lenses in your eyes on to your retinas. They send electrical impulses along the optic nerves to your cerebral cortex. There your brain interprets these impulses and constructs a mental image.

This, surprisingly, is an acquired ability. Patients who have had their eyesight restored after having been blind from birth at first see only light. They have to learn how to construct a mental image.

Pictures exist on a mental level that may be coincident with the depictive level — what the picture is showing — but does not mirror it. The mental level elaborates, refines, and embellishes our perceptions of the depictive level. The mental level of a photograph provides a framework for the mental image we construct of (and for) the picture.

While the mental level is separate from
the depictive level, it is honed by formal
decisions on that level: choice of vantage
point (where exactly to take the picture
from), frame (what exactly to include),
time (when exactly to release the shutter),
and focus (what exactly to emphasize
with the plane of focus). By focusing
on the black void at the end of this
impossibly narrow ally, Thomas Annan
draws our mental focus through the
confined space of the image. Focus is the
bridge between the mental and depictive
levels: focus of the lens, focus of the eye,
focus of attention, focus of the mind.

Thomas Annan
Close, No. 61 Saltmarket
1868–77

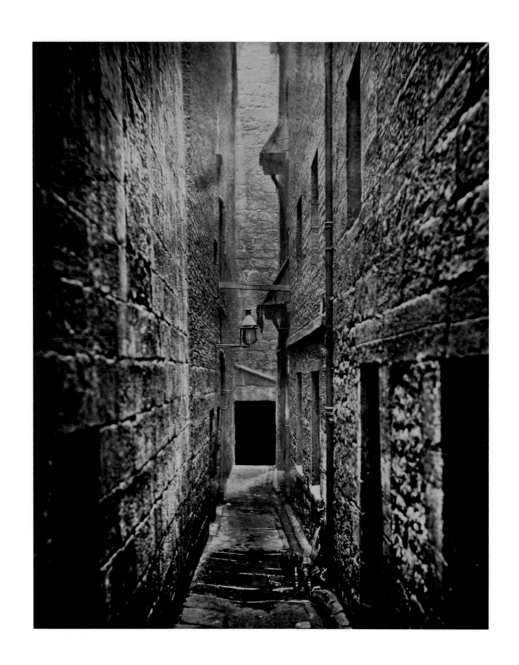

A photograph may have deep depictive
space but shallow space on the mental
level — in which there is little sensation
of your eye changing focus.

William H. Bell
Cañon of Kanab Wash,
Colorado River,
Looking South
1873

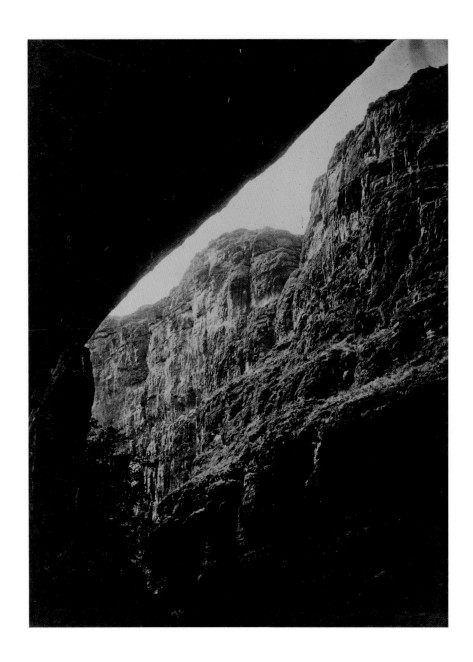

Conversely, a photograph may have
shallow depictive space but deep
mental space.

Frederick Sommer
Glass, 1943

A photograph may utilize structural
devices to emphasize deep space (layering
of planes, receding diagonals, verticals
in tension with the edges, etc.) but have
shallow mental space.

Berenice Abbott
Department of Docks,
New York City, 1936

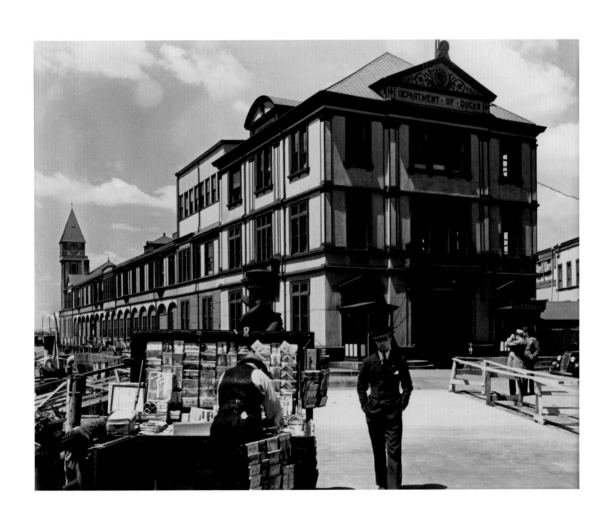

A photograph may have a relatively
uninflected structure but have recessive
mental space.

Paul Caponigro
<u>Peach, Santa Fe,</u>
<u>New Mexico, 1989</u>

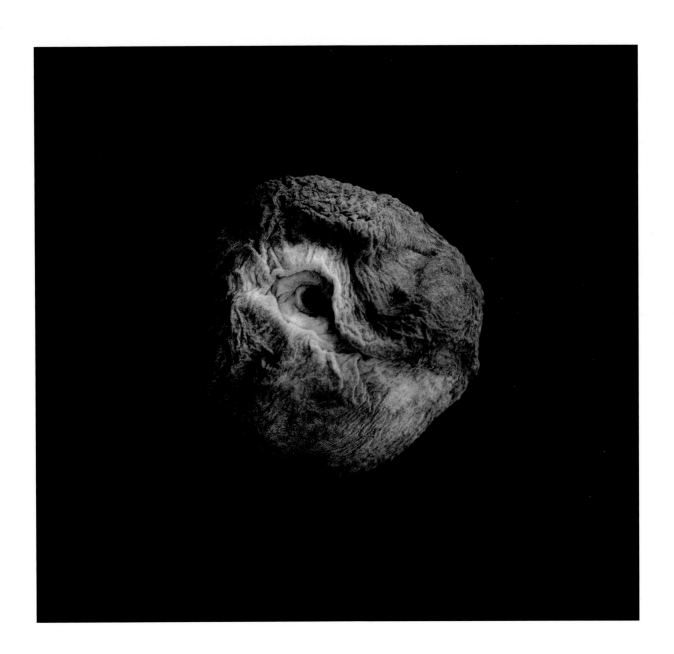

In this Walker Evans photograph
track your focus through the space
of the picture.

Look at the sky in relation to the rest
of the picture.

Unlike the Adams photograph of the
drive-in theatre where the sky moved
forward, the sky here appears to float
on a different plane, as though it were
cut out from a different picture, as
though it were a collage. This collaging
appears when there is a difference in
the degree of attention a photographer
pays to different parts of the picture.
For this to happen, the photographer
needs to pay intense, clear, heightened
attention to one part of the picture,
but not to another.

Walker Evans
Gas Station, Reedsville,
West Virginia, 1936

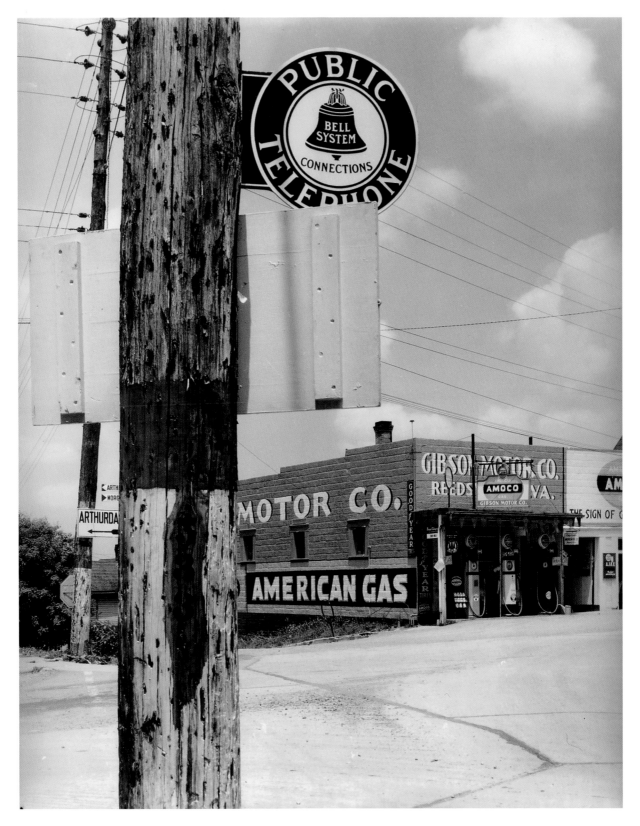

The crystalline clarity of Garry
Winogrand's awareness of a photograph
cutting through motion and time makes
this image of people interacting on
a bench absolutely riveting. The quality
and intensity of a photographer's
attention leave their imprint on the
mental level of the photograph. This
does not happen by magic.

A photographer's basic formal tools
for defining the content and organization
of a picture are vantage point, frame,
focus, and time. What a photographer
pays attention to governs these decisions
(be they conscious, intuitive, or auto-
matic). These decisions resonate with the
clarity of the photographer's attention.
They conform to the photographer's
mental organization — the visual gestalt
— of the picture.

If you right now become aware of
the space between yourself and this
page, there is a transmutation of your
attention and perception. This sort of
perceptual change — this modification
of the mental image — would, for a
photographer, lead to a realignment
of his or her formal decisions in
making a photograph.

Garry Winogrand
World's Fair,
New York City, 1964

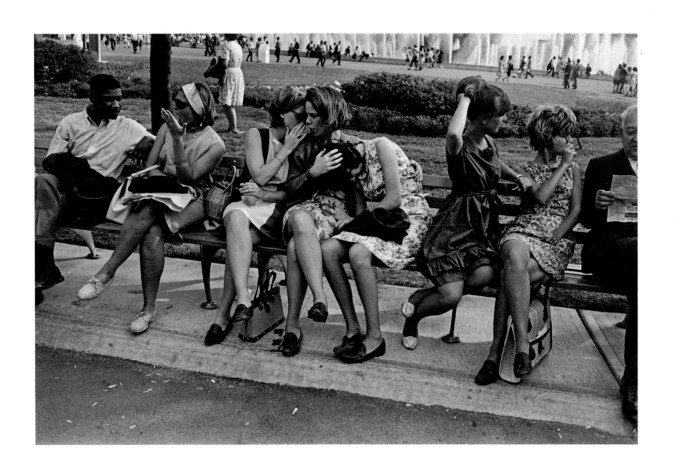

Gustave Le Gray

<u>The Beech Tree</u>

c. 1856

William Eggleston
<u>Untitled</u>
c. 1970

Emmet Gowin
Wadi Siyagh, Petra,
Jordan, 1982

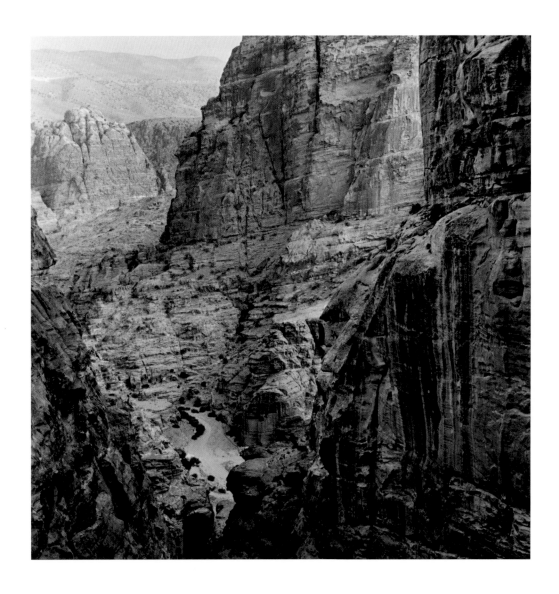

Dorothea Lange
<u>Second Born, Berkeley,</u>
<u>1955</u>

Mental Modelling

The mental level's genesis is in the photographer's mental organization of the photograph. When photographers take pictures, they hold mental models in their minds; models that are the result of the proddings of insight, conditioning, and comprehension of the world.

At one extreme, the model is rigid and ossified, bound by an accumulation of its conditioning: a photographer recognizes only subjects that fit the model, or structures pictures only in accordance with the model. A rudimentary example of this is a mental filter that permits only sunsets to pass through. At the other extreme, the model is supple and fluid, readily accommodating and adjusting to new perceptions.

For most photographers, the model operates unconsciously. But, by making the model conscious, the photographer brings it and the mental level of the photograph under his or her control.

Earlier I suggested that you become aware of the space between you and the page in this book. That caused an alteration of your mental model. You can add to this awareness by being mindful, right now, of yourself sitting in your chair, its back pressing against your spine. To this you can add an awareness of the sounds in your room. And all the while, as your awareness is shifting and your mental model is metamorphosing, you are reading this book, seeing these words — these words, which are only ink on paper, the ink depicting a series of funny little symbols whose meaning is conveyed on the mental level. And all the while, as your framework of understanding shifts, you continue to read and to contemplate the nature of photographs.

Diane Arbus
<u>Woman on a Park Bench</u>
<u>on a Sunny Day, N.Y.C.</u>,
<u>1969</u>

Lee Friedlander
Idaho 1972

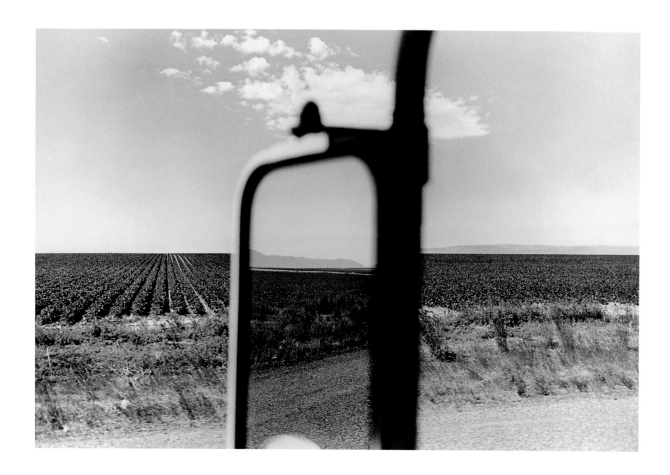

Fazal Sheikh
<u>Darmi Halake Gilo,</u>
<u>Sololo, Kenya, 1992—93</u>

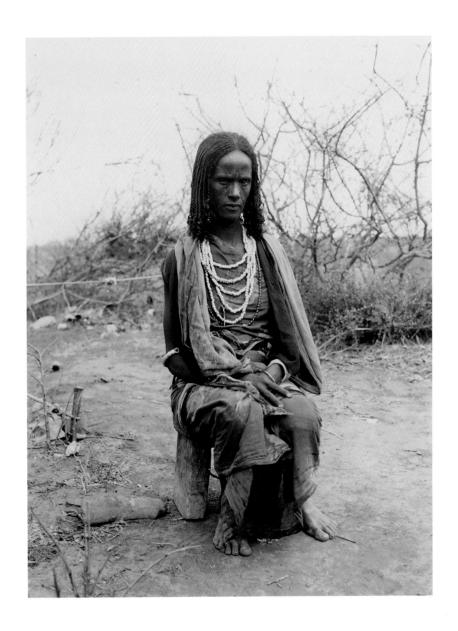

Frederick Sommer
<u>Virgin and Child with</u>
<u>St. Anne and the Infant</u>
<u>St. John, 1966</u>

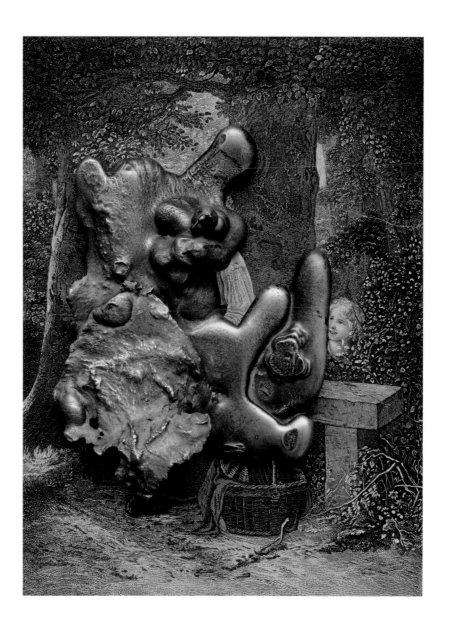

Each level of a photograph is determined by attributes of the previous level. The print provides the physical framework for the visual parameters of the photographic image. The formal decisions, which themselves are a product of the nature of that image, are the tools the mental model uses to impress itself upon the picture. Each level provides the foundation the next level builds upon. At the same time, each reflects back, enlarging the scope and meaning of the one on which it rests. The mental level provides counterpoint to the depictive theme. The photographic image turns a piece of paper into a seductive illusion or a moment of truth and beauty.

Eugène Atget
Oriental Poppy
Date unknown

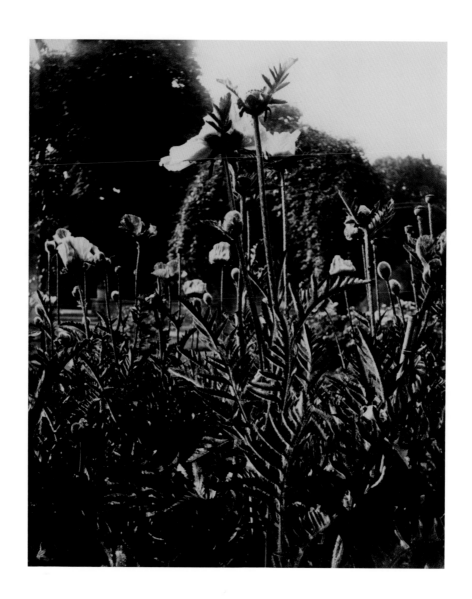

August Sander
<u>Jobless</u>
1928

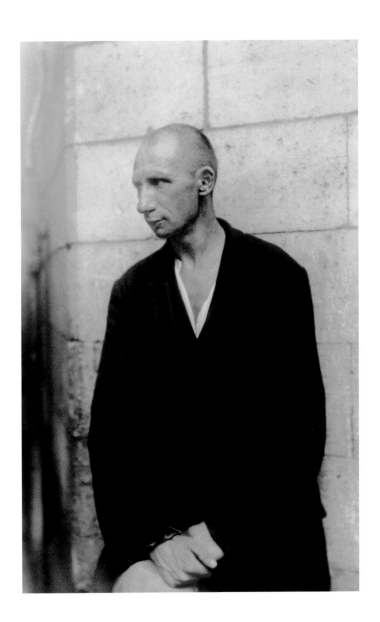

An-My Lê
Ambush II
From
'Small Wars'
1999—2002

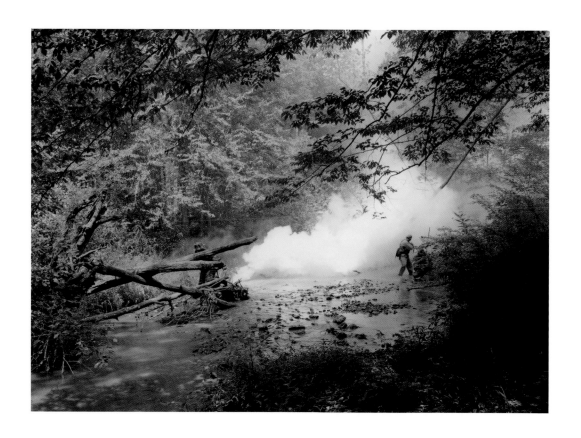

Jeff Wall
<u>Man in Street</u>
1995

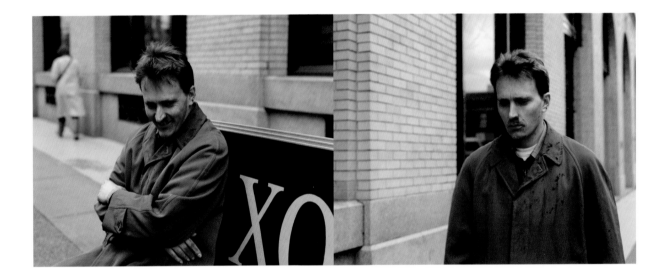

William Eggleston
Untitled
c. 1983

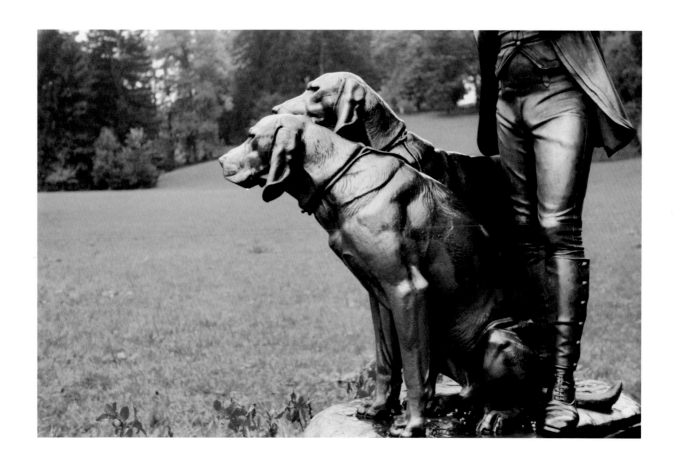

Lee Friedlander
<u>New York</u>
1966

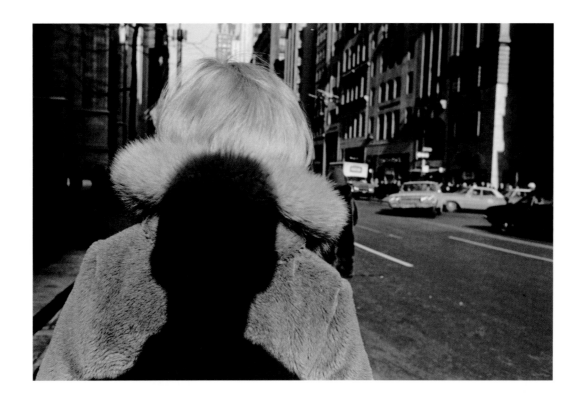

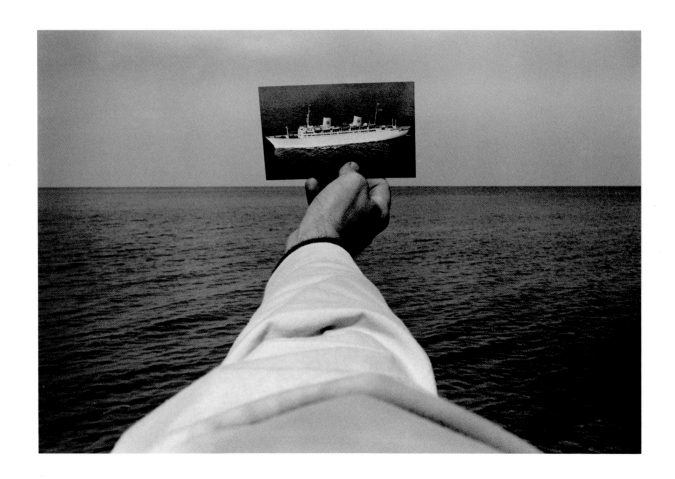

Tim Davis
<u>Still Life with Apples</u>
2003

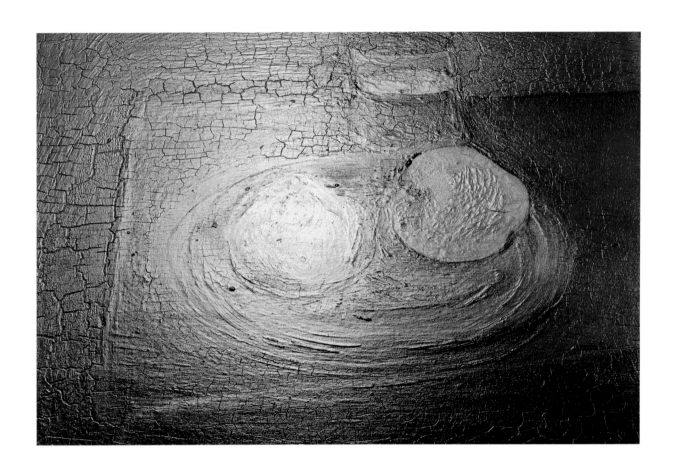

Andreas Gursky
<u>Greeley</u>
2003

When I make a photograph, my
perceptions feed into my mental
model. My model adjusts to accommodate
my perceptions (leading me to
change my photographic decisions).
This modelling adjustment alters,
in turn, my perceptions. And so
on. It is a dynamic, self-modifying
process. It is what an engineer would
call a feedback loop.

It is a complex, ongoing, spontaneous
interaction of observation, understanding,
imagination, and intention.

Stephen Shore
Yucatan, Mexico, 1990

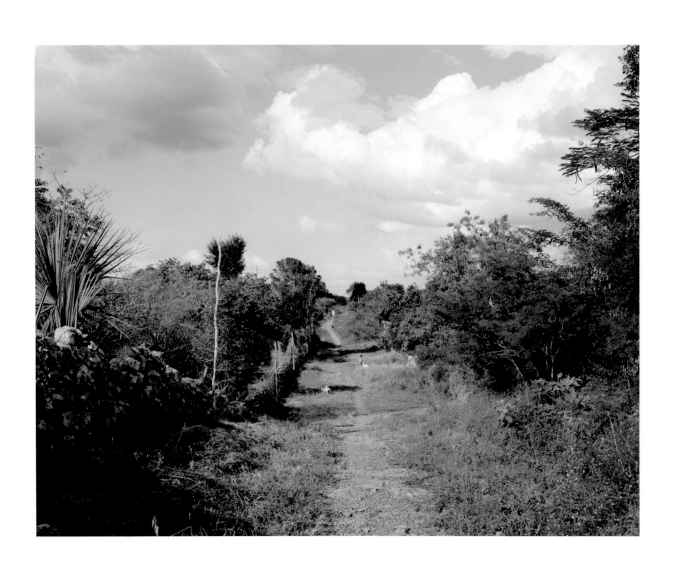

Picture Credits

6 Copyright Robert Frank, from 'The Americans', courtesy Pace/MacGill Gallery, New York; 9 Copyright John Gossage; 11 Galerie Rudolf Kicken. Courtesy of Dieter Appelt; 13 Library of Congress; 14 Collection of Stephen and Ginger Shore; 17 Courtesy 303 Gallery, New York; 19 Photo copyright 1986 © Anne Turyn; 20 Courtesy 303 Gallery, New York; 21 Courtesy of the artist and Luhring Augustine, New York; 22 Courtesy 303 Gallery, New York; 23 Courtesy of the artist and 303 Gallery, New York; 25 Courtesy Richard Benson; 27 Collection of Stephen and Ginger Shore; 28 Courtesy of the artist and Metro Pictures Gallery; 30 George Eastman House; 31 U.S. Geological Survey; 32 Courtesy 303 Gallery, New York; 33 Courtesy of Bernd and Hilla Becher; 35 Library of Congress; 36 top © Andrew L. Moore/courtesy Yancey Richardson Gallery; 36 bottom Courtesy of the artist and Yancey Richardson Gallery; 39 Library of Congress; 41 The J. Paul Getty Museum; 43 Courtesy Fraenkel Gallery, San Francisco; 44–7 © Thomas Struth, 2005; 49 Copyright Estate of André Kertész, courtesy of Silverstein Photography, New York; 50 Courtesy Baudoin Lebon Keitelman; 51 ©

Zeke Berman, courtesy Laurence Miller Gallery, New York; 52–3 Courtesy Fraenkel Gallery, San Francisco; 55 Courtesy Fraenkel Gallery, San Francisco; 57 Courtesy Aaron Diskin; 59 © Helen Levitt, courtesy Laurence Miller Gallery, New York; 61 © 2006 Eggleston Artistic Trust, courtesy Cheim and Read, New York. Used with permission. All rights reserved; 63 Courtesy 303 Gallery, New York; 66 Copyright of the artist, courtesy Anthony Reynolds Gallery; 67 Copyright Philip-Lorca diCorcia, courtesy Pace/MacGill Gallery, New York; 68–9 Copyright Richard Prince. Photos: David Regen. Courtesy Gladstone Gallery, New York; 71 © The Estate of Garry Winogrand, courtesy Fraenkel Gallery, San Francisco; 73 Courtesy Larry Fink; 75 Courtesy Linda Connor; 77 Collection Center for Creative Photography ©1981 Arizona Board of Regents; 78 Courtesy Tod Papageorge; 79 Courtesy Frank Gohlke; 80 © Bettmann/CORBIS; 81 Courtesy Michael Schmidt; 83 The J. Paul Getty Museum 85 Courtesy Fraenkel Gallery, San Francisco; 87 Courtesy Janet Borden, Inc., New York; 89 © ESTATE BRASSAÏ – R.M.N. © Photo RMN/ © Adam Rzepka; 91 Copyright Judith Joy

Ross, courtesy Pace/ MacGill Gallery, New York; 93 © Vik Muniz and the Estate of Hans Namuth/VAGA, NY, courtesy Fortes Vilaça Gallery, Sikkema, Jenkins & Co. & Xippas Gallery; 94 © Black River Productions, Ltd/Mitch Epstein; 95 Courtesy Guido Guidi; 96 Copyright Paul Caponigro. Used by permission; 99 The J. Paul Getty Museum; 101 The J. Paul Getty Museum; 102–3 © Frederick & Frances Sommer Foundation; 105 BereniceAbbott/ Commerce Graphics Ltd, Inc; 107 Copyright Paul Caponigro. Used by permission; 109 Library of Congress; 111 © The Estate of Garry Winogrand. Courtesy Fraenkel Gallery, San Francisco; 112 The J. Paul Getty Museum; 113 © 2006 Eggleston Artistic Trust, courtesy Cheim and Read, New York. Used with permission. All rights reserved; 114 Copyright Emmet and Edith Gowin, Courtesy Pace/MacGill Gallery, New York; 115 © The Dorothea Lange Collection, The Oakland Museum of California, City of Oakland. Gift of Paul S. Taylor; 116 George Eastman House. Courtesy the Georgia O'Keefe Foundation; 117 © 1972 The Estate of Diane Arbus LLC; 119 Courtesy Fraenkel Gallery, San Francisco;

120 Courtesy Fazal Sheikh; 121 © Frederick & Frances Sommer Foundation; 123 Collection of Stephen and Ginger Shore; 124 © Die Photographische Sammlung/SK Stiftung Kultur – August Sander Archiv, Cologne; DACS, London, 2006; 125 Courtesy Murray Guy, New York; 126 Courtesy Jeff Wall; 127 © 2006 Eggleston Artistic Trust, courtesy Cheim and Read, New York. Used with permission. All rights reserved; 128 Courtesy Fraenkel Gallery, San Francisco; 129 Courtesy Ken Josephson; 130 Courtesy Tim Davis; 131 Copyright Andreas Gursky, courtesy Monika Sprüth /Philomene Magers; 133 Courtesy 303 Gallery, New York; 135 Copyright John Szarkowski. Courtesy Pace/MacGill Gallery, New York.

Index of Artists

Acknowledgements

This book grew out of a course I have taught
for many years at Bard College in Annandale-
on-Hudson, New York. When I first started
teaching the course, I used John Szarkowski's
The Photographer's Eye as a text and without
it as a precedent The Nature of Photographs
would not have been written.

The first draft was written while I was a
fellow at the MacDowell Colony in New Hampshire.
The combination of solitude during the day and
lively conversation at dinner helped me keep
my focus. While there, the early stages of this
project benefited from the advice of Michael
Almereyda. The present work evolved over several
years. I am especially grateful to James Enyeart,
Charles Hagen, and George F. Thompson of the
Center for American Places, the publisher of
the first incarnation of this book, for the time
they took to make detailed comments on my
manuscript.

My understanding of the importance of focus
was stimulated by Amos Gunsberg. For a description
of the mechanics of seeing, I have referred to
Seeing with the Mind's Eye (1975) by Mike and
Nancy Samuels.

Without the cooperation of all the photographers,
galleries, and institutions who allowed me to
reproduce work, this book would not have been
possible. I particularly wish to thank Weston
Naef of the Getty Museum, Peter MacGill of
PaceMacGill, and Lisa Spellman and Mari Spirito
of 303 Gallery. My interest in photography
and perception continues to be stimulated by
conversations with Jeff Rosenheim of the
Metropolitan Museum of Art, with Pietro
Perona of CalTech, and with Michael Fried of
Johns Hopkins. I have also learned much from my
colleagues at Bard College, Laurie Dahlberg,
Tim Davis, Barbara Ess, Larry Fink, An-My Lê,
John Pilson, and Luc Sante, as well as from
my students.

At Phaidon Press, I'm deeply indebted to Amanda
Renshaw, Alex Stetter and Paul McGuinness for their
wisdom and insight throughout the whole process of
producing this book, to Scott Williams and Henrik
Kubel for their elegant design, and to Richard
Schlagman for his continued support.

Finally, I am indebted to my wife, Ginger, for her
council and encouragement.

John Szarkowski
Mother
1998